URBAN GIRLS

Authors
Gary Barker and Felicia Knaul
Updated by Neide Cassaniga with Anita Schrader
Consortium for Street Children UK

Advisory Group
Dr Irene Rizzini (Director, Centre for Research on Childhood,
University of Santa Ursula, Brazil)
Dr Marilyn Thomson (Gender Specialist, Save the Children UK)
Dr Kate Young (Director, Womankind Worldwide)
Helen Veitch (Coordinator ECPAT/UK)
Jonathan Blagbrough (Child Labour Specialist,
Anti-Slavery International UK)

Project Coordinator
Anita Schrader, Consortium for Street Children UK
Edited by
Peter Pattison and Dr Melanie Mauthner

Funded by
The Department for International Development UK (1997–98)
and UNICEF, Urban Section, New York (1991–92)

URBAN GIRLS

Empowerment in Especially Difficult Circumstances

GARY BARKER and FELICIA KNAUL
with NEIDE CASSANIGA and ANITA SCHRADER

INTERMEDIATE TECHNOLOGY PUBLICATIONS 2000

Intermediate Technology Publications Ltd
103–105 Southampton Row, London WC1B 4HL, UK

© The Consortium for Street Children UK 2000

A CIP record for this book is available from the British Library

ISBN 1 85339 475 0

The views expressed in this publication are not necessarily those of the member agencies of the Consortium for Street Children or of our funders, the Department for International Development and World Vision UK

Typeset by J&L Composition Ltd, Filey, North Yorkshire
Printed in the UK by SRP, Exeter

Dedicated to the memory of
Marcia Dangremon
23 August 1940–21 October 1999
Founder of the Colectivo Meninha Mulher
who lived solidarity

Contents

Foreword	x
About this publication	xi
Acknowledgments	xiii

Introduction 1
- Box 1: Landmark treaties and conventions on women and girls 3
- Box 2: The strategic objectives from Section L of the Beijing Platform for Action (1995) 3
- Box 3: Why is investing in girls and young women important? 4

Chapter 1: Especially Difficult Circumstances 7
Definition of terms 7
Street girls 8
- Table 1: Street and working girls: comparison of selected studies 1987–98 10

Urban girls at work 12
Commercial sexual exploitation 17
Teenage mothers 21
- Box 4: Research in Tanzania 24
- Table 2: Births to adolescent mothers world-wide (selected countries) 25

Identifying needs and programme responses 25

Chapter 2: Income Generation and Vocational Training 29
Introduction 29
Case study: Youth Skills Enterprise Initiative (YSEI), Street Kids International (SKI); Zambia 30
Case history: Profile of three participants of the Youth Skills Enterprise Initiative 34
Model programme: Servol Life Centres: Education for life and work; Trinidad and Tobago, West Indies 36
Model programme: Child Welfare Society of Kenya: Empowering domestic workers 38
Model programme: The SIMMA Vocational Training Institute and the WACAR Foundation: Empowerment of women for better prospects and sustainable development; The Gambia 40
Elements of success: Income generation and vocational training 42

Chapter 3: Formal and Non-formal Education **45**
Introduction 45
Case study: Adolescent Mothers Programme of the Women's Centre of Jamaica Foundation: A second change for education 46
Case history: Ellorine, from teen mother to nurse; Jamaica 49
Model programme: Enda: Literacy for domestic workers; Dakar, Senegal 50
Model programme: Paaralang Pantao: Children's Laboratory for Drama in Education and The People's School; Manila, The Philippines 51
Elements of success: Formal and non-formal education 54

Chapter 4: Health and Mental Wellbeing **57**
Introduction 57
Case study: Casa de Passagem: Health outreach by and for girls; Recife, Brazil 58
Case history: Betania, from street girl to mother; Brazil 61
Model programme: Kabalikat, Philippines: Health education for street children and bar workers; Manila, the Philippines 62
Model programme: Undugu Society of Kenya: 'Outward bound' for street girls; Nairobi, Kenya 64
Elements of success: Health and mental wellbeing 65

Chapter 5: Culture **67**
Introduction 67
Case study: Sasha Bruce Teen Mothers Programme: Rites of passage for African-American girls; Washington, DC, USA 68
Model programme: FACT: AIDS education through art; Bangkok, Thailand 72
Model programme: African Culture International: Theatre of change, theatre of tradition; Dakar, Senegal 74
Model programme: Kapatiran-Kaunlaran Foundation: Linking the elderly and youth; Manila, the Philippines 75
Elements of success: Culture 76

Chapter 6: Advocacy and Protecting Girls' and Young Women's Rights **79**
Introduction 79
Model programme: The Kamla Project: Preventing sexual exploitation of girls; Thailand 81
Model programme: ECPAT: Legislation against cross-border sexual exploitation of children; Worldwide network 83
Model programme: Inter-African Committee on Traditional Practices Affecting the Health of Women and Children: Confronting harmful traditions 85

Model programme: Heart-to-Heart: Preventing sexual abuse among adolescent mothers and their children; Chicago, USA	86
Elements of success: Advocacy and rights	88

Chapter 7: Involving Boys and Men in Efforts to Improve Young Women's Lives — 91

Introduction	91
Reflections on working with adolescent boys in the reproductive-health field	92
Reflections on involving men in the prevention of domestic violence	94
Programme examples in working with adolescent boys	95
Case study: The experience of SIDH in India	95
Case study: ECOS's experience in Brazil	95
Case study: The experience of the Ounce of Prevention Fund in the USA	96
Lessons learned from work with adolescent males in gender equity	97
Conclusions	98

Chapter 8: Conclusions — 101

Advocacy recommendations	101
Service recommendations	103
Looking to the future	106
References and Bibliography	107
Consortium for Street Children Profile	119
CSC members working with at-risk girls and young women	120

Foreword

A decade ago, the UN Convention on the Rights of the Child (CRC) came into force in the United Kingdom and in almost every other country of the world. One of the most far-sighted of all global human rights instruments, it brings hope for a better world – for all children. Yet the daily struggle of millions of children, to survive and to find love and dignity, is a shaming indictment of the ways in which our societies oppress and neglect the most vulnerable young.

Transforming the rights enshrined in the CRC into reality for the most disadvantaged children is probably one of the toughest and most complex tasks faced by humanity today. It will take a multi-faceted approach, including setting new standards for child protection and participation – then enforcing their practice. As an international community we have made progress on setting new standards: as an example the International Labour Organisation's Convention No. 182 has outlawed the worst forms of child labour including debt bondage, hazardous work, and the commercial sexual exploitation of children. And the last ten years have witnessed some real improvements in healthcare and the reduction of child mortality, in access to education by boys and girls, in the use of legal mechanisms to protect children, and in children's awareness of their basic rights.

This book describes ways in which urban girls who survive in especially difficult circumstances are learning to recognise and gain access to their rights. This process is a slow and painful but steady one, which has borne fruits. *Urban Girls* describes the way in which girls who are very poor and deprived can be and have been helped to gain confidence in themselves, and find better opportunities for their own futures and those of their children.

I congratulate the Consortium for Street Children for the solidarity it offers, and the encouragement it gives to programmes which help these girls and other vulnerable youth transform rights into reality. This book is a valuable contribution to bringing children and their rights together.

Cherie Booth, QC

About this publication

This publication aims to contribute to a discussion on the way in which at-risk and low-income adolescent girls and young women can be helped towards a better life by providing examples of low-cost programmes that non-governmental organizations and governments have established to this end. Attention is focused on four 'especially difficult circumstances': street living, work (with a particular emphasis on domestic servitude), sex work, and teenage motherhood.

The publication is based on a much longer unpublished study commissioned by UNICEF in 1991, and it outlines the way in which certain programmes have responded to the needs of urban girls and summarizes some of the conclusions which these have reached.

The programmes described in this publication represent only a handful of NGOs (non-governmental organizations) active in this field. When possible, the original authors made site visits to the organizations (in the case of organizations in the US, Brazil, Kenya, Thailand, Senegal, Trinidad, Jamaica and the Philippines). Site visits involved interviews with agency directors, staff, and young women (when possible), and review of relevant documents. For other organizations included here, information was gathered via a questionnaire, telephone interviews and document review. In other instances, case studies were submitted or developed in close collaboration with a partner organization, such as in the case of SKI (Street Kids International) and SIMMA. The original site visits were carried out during 1991 and 1992.

In 1998, the Consortium for Street Children UK (CSC) secretariat, with the support of the Department for International Development, and with the permission of UNICEF and the authors, decided to update the material and have it published. All the Consortium for Street Children member agencies which work with at-risk girls and young women were consulted and their suggestions and comments were incorporated. An extra chapter has been included, looking at the ways boys and men can be involved in this kind of project.

We recognize that one of the features or characteristics of many programmes working with youth in general, and at-risk young women in particular, is their flexibility and evolution over time. Between the time of the original case studies and this publication, some features or aspects or

programmes have been changed, modified or even eliminated. In other cases, funding has not been stable or has not permitted programmes to continue. In yet other cases, new programmes or programme aspects have been added. In every instance, an effort was made to include the most recent information about a programme.

Acknowledgments

In addition to the programmes described in this publication, which provided us with information and hospitality, the authors would like to thank the following individuals and organizations for their invaluable assistance with this publication.

1991–2
Victoria Rialp at UNICEF/ New York
Migdalia Fuentes, UNICEF/New York
Clarence Shubert, UNICEF/New York
Marilyn Rocky, CHILDHOPE
Advocates for Youth, US
CHILDHOPE offices in Brazil and the Philippines
International Catholic Child Bureau, Geneva, New York and Montevideo offices
UNICEF offices in Bogota, Nairobi, Brasilia, Dakar, Manila, Bangkok
Judith Musick

1997–8
Christine Beddoe, ECPAT
Jonathan Blagbrough, Anti-Slavery International
Janet Brown, University of West Indies, Jamaica
Ana Capaldi, CSC UK
Chapin Hall Centre for Children, University of Chicago, US
Gisella Hanley, University of California, Los Angeles, US
Satang Jobarteh, SIMMA, The Gambia
Dita Reichenberg at UNICEF/New York
Dr Irene Rizzini, University of Santa Ursula
Dr Richard Slater, University of Birmingham, UK
Dr Marilyn Thompson, Save the Children Fund UK
Peter Copping and Ann Sutherland, Street Kids International, Canada
Helen Veitch, ECPAT UK
David Westwood, World Vision UK

Thanks are also due to Peter Pattison and Dr Melanie Mauthner for editing the text and for their many valuable comments; and to the Department for International Development for funding the project. Thanks to David Ould, Anti-Slavery International and World Vision UK for particularly consistent and generous support and help in kind; staff of Intermediate Technology Publications, and in particular Neal Burton and Ina Gutzeit; and to Shelley Collins, Christina Janke, Catherine Maidment and Roberta

Vocaturo for their help throughout. The project co-ordinators would also like to thank Martine Miel, Rose McCauseland, Murray and Zania McMillan, Elizabeth McMillan, Joanne Roberts, J.C.E. Schrader, Alan Simmonds and Dr Adam Steinhouse.

Neide Cassaniga and Anita Schrader, Consortium for Street Children UK

Introduction

'When goods are sold they do not know how to cry, when a woman is sold, no matter how hard she weeps, the one who sells her will never hear.'

(Quote from the banner of a Thai child)

'Late in the evening, a group of 10 young women, all domestic workers, gather in a small classroom for literacy classes in a low income area of Dakar, Senegal. They listen attentively as the teacher reviews basic French grammar. As the class proceeds a few begin to sleep, unable to stay awake after their 13- and 14-hour work days. They have all migrated to the city because drought has led to low crop yields in their arid village. They sleep 20 to a room. Why do they attend the literacy classes? For a slim chance to work in a household where they will be better paid for being literate in French.'

(Barker and Knaul site visit)

BETWEEN 1959 AND 1990 the population of the world's cities multiplied by eight, from 200 million to approximately 2 billion, with three billion expected by the year 2025. Today, there are 20 cities of over 10 million people, and 19 of the world's largest 25 cities are in the developing world. (Giardet, 1992).

This shift has had enormous consequences for women, and much has been written about the double burden they face in supporting children and working, particularly in the absence of a partner: female-headed households, which comprise up to 50 per cent of all households in Latin American cities, are also among the poorest sectors of the population. Less has been written about the impact of urban poverty on adolescent girls and young women, who often find themselves at a crossroads between cultural mores that work against them, and the demands of survival in cities, which require increasingly complex skills. In some regions, urban growth has taken place alongside – and has indeed catalysed – greater gender equity; in parts of Latin America and the Caribbean, women and girls have entered the formal-sector workforce and education in greater proportions; in other regions, notably South-East Asia and sub-Saharan Africa, great disparity continues to exist. But within the mass of urban poor, adolescent girls are at a disadvantage – to face especially difficult circumstances – on four grounds: their age; their gender; their poverty; and, often, their ethnicity.

In many cases, the problems facing urban girls and young women represent generational cycles of discrimination which are passed from mother to

daughter. In addition, the inequalities affecting these women start even before birth, due to pre-natal selection, and in some cultures, female infanticide. During childhood, girls may receive less food and healthcare than their brothers. On reaching adolescence there is a greater likelihood that they will have to drop out of school, and in some countries they probably face genital mutilation. In their childbearing years they run a high risk of death or injury during childbirth or through botched abortion.

In the past two decades there has also been an expansion in grass-roots, non-governmental, and governmental policies addressing the needs of urban women and children. There have been important gains in expanding credit, education and non-traditional income-generation possibilities for women. In addition, increased attention to maternal and child health has reduced levels of infant and maternal mortality in many regions of the world. There has been a dramatic rise in the number of programmes for 'street children' – albeit mostly boys. A number of these projects have assisted street children by providing new income-generation possibilities (Barker and Knaul, 1990). However, adolescent girls have tended to fall through the cracks of programme activity – too young to be 'women', too old to be children.

Throughout the document, we have used the ages 10 to 19 in accordance with WHO's definition of adolescence. However, on occasions we have emphasized girls aged 18 and under, which is the population of young people protected by the 1989 Convention on the Rights of the Child. In other cases, programmes work with young women up until their early twenties.

While it may be difficult to break cycles of discrimination and urban poverty, recent experience shows that it can be done. In all cases where change was necessary – child survival, street children, maternal health, women's education and access to credit – both national and international campaigns preceded direct action and subsequent improvements. Many coalitions were formed and a number of conventions were organized and treaties signed (see Box 1).

In 1998, a follow-up meeting on the Beijing Conference reported improvement in girls' access to education in many countries. However, there are still matters of huge concern: despite international and national efforts, for example, it seems there has been no improvement in the physical and psychological violence suffered by girls and young women (NGOs Working Group on Girls, 1998).

The Convention on the Rights of the Child, signed in 1989, has been used by advocates around the world to lobby for law reforms in their own countries. It calls on States Parties to safeguard children from sexual exploitation, abuse and involvement in pornography. The Convention also obliges States Parties to respect all children's rights without discrimination (Article 2). Thus, the Convention applies the same rights of survival,

> **Box 1: Landmark treaties and conventions on women and girls**
>
> o The Convention on the Elimination of Discrimination against women (1979)
> o The Convention on the Rights of the Child (1989)
> o The World Conference on 'Education for All' (held in Jomtien in 1990)
> o The UN Fourth World Conference on Women (held in Beijing in 1995)
> o The World Congress against Commercial Sexual Exploitation of Children (held in Stockholm in 1996).

protection, and development to every child – regardless of class, ethnicity, age or gender.

In the agenda for action set by the participants at the Beijing Conference in 1995, governmental organizations and NGOs have committed themselves to the course of action described in Box 2.

Inspired by the important gains of the programmes and initiatives to assist children and women, member agencies of the Consortium for Street Children UK have been working for the inclusion of girls and urban young

> **Box 2: The strategic objectives from Section L of the Beijing Platform for Action (1995)**
>
> o Eliminate all forms of discrimination against the girl-child
> o Eliminate negative cultural attitudes and practices against girls
> o Promote and protect the rights of the girl-child and increase awareness of her needs and potentials
> o Eliminate discrimination against girls in education, skill development and training
> o Eliminate discrimination against girls in health and nutrition
> o Eliminate the economic exploitation of child labour and protect young girls at work
> o Eradicate violence against the girl-child
> o Promote the girl-child's awareness of and participation in social, economic, and political life
> o Strengthen the role of the family in improving the status of the girl-child
>
> Source: NGOs Working Groups on Girls, 1998.

women in action agendas. There is sufficient evidence to show that investing in programmes for young women is both cost-effective and important (see Box 3). However, since young women have been left out of many development efforts, special intensive services are still needed to help them catch up.

By looking at the experience of programmes, this publication endeavours to answer two questions:

- What do at-risk urban girls and young women need?
- What kind of programmes have been successful in meeting those needs?

Box 3: Why is investing in girls and young women important?

- It helps break cycles of poverty and exploitation. The daughters of adolescent mothers are themselves more likely to be adolescent mothers (Kahn and Anderson, 1992), just as daughters of women who were sexually abused in the home are more likely to be sexually abused (Musick, 1993).
- The return to the investment continues into future generations. The World Bank concludes that investment in education for girls probably brings even higher returns than education to boys because educated women ensure that their families are educated and healthy (Floro and Wolf, 1990).
- Providing information and services on reproductive health to a young woman minimizes the chance that she will have an early, high-risk pregnancy or suffer from the complications of an unsafe, backroom abortion – both of which strain the budgets of national health systems and lead to needless suffering. Women who start their childbearing later, are better able to care for their children, and tend to have a smaller overall family size. It will also empower them to take control over their body and negotiate safe sex (Hirsch and Barker, 1992).
- The patterns of emotional and psychological development during adolescence heavily influence whether a girl reaches womanhood with high self-esteem or whether she enters into destructive and dependent relationships with men. Young women with low self-esteem have lower educational attainment and are less likely to take advantage of income-generation opportunities (Musick, 1993; Barker and Musick, 1994).

In summary, investment in training and education for young women makes them productive members of society who contribute to their own, their family's and their society's welfare and income.

The overwhelming conclusion that emerges is that we can pay now for services for girls and young women and help future generations in the process, or we can condemn them to repeating cycles of poverty and second-class status.

1. Especially Difficult Circumstances

'Please do not listen to us as "girls" but as women leaders of tomorrow'
(Plea from the girls participating in the NGOs Forum on
the Girl Child, *quoted in* Thomson, M. 1998)

THOSE GIRLS WHO live on the streets, who are exploited through their work, who are sexually exploited, or who are teenage mothers represent only a fraction of low-income adolescents. Most poor urban girls face the less visible but equally severe challenges of poverty and low status. For every girl living on the street or involved in sex work there are very many more who experience coercion in their relationships, who lack information about their bodies, who have no access to healthcare and who have very limited possibilities of education. Moreover, most adolescents, whatever their background, desire more or less the same things. The categories we consider in this publication omit young women in institutions or prisons, and the disabled, who also face significant difficulties.

Definition of terms

It is useful to clarify some of the terms we use in this publication, since these are often used differently and/or interchangeably.

Street girls: Girls or young women under the age of 18 who spend most or all of the time on the street or in other public spaces, and who have limited or no contact with their family or with responsible adults.

Working girls: Girls or young women under the age of 18 who work, with or without other family members, in exchange for cash or goods – either in open spaces (such as street markets) or enclosed environments such as other people's homes.

Girls subject to commercial sexual exploitation: Girls or young women who are used for the sexual satisfaction of adults. Although it is now considered more appropriate to call adult women involved in prostitution 'sex workers' neither term communicates the lack of control experienced by a child or adolescent in this situation. All children under the age of 18 who are in prostitution are being sexually exploited according to the standards set by the Convention on the Rights of the Child and, more recently, the International Labour Organisation.

Teenage mothers: Girls or young women who have given birth before the age of 20.

These 'especially difficult circumstances' are not homogeneous categories. Girls who have run away from domestic work may have no option but the street and, while there, are likely to be sexually exploited by others and/or engage in sex work. The same is true of girls who have been thrown out of their homes because of pregnancy.

Street girls

'I have been a street girl since my father made a "woman" of me. I carry on in the world but I am really dead.'
(17 year-old street girl *cited in* Ewart-Biggs, K. 1990)

Statistics on 'street children' are notoriously unreliable, partly because of the difficulty in surveying a mobile population, partly because of problems in defining the term. In fact, the proportion of children who live on the streets or other open urban spaces is small in relation to a much larger population of urban working children. A study in Peru suggested that of the population of 50,000 urban working children, perhaps 2,000 were street living, and of these, an even smaller population – about 200 – were girls (Ordonez, 1995). In Brazil, which has a much larger population (and a higher number of street-living children) the ratio of boys to girls varies from city to city: 13 per cent in Rio de Janeiro, 14 per cent in Salvador, 14 per cent in Recife, and 10 per cent in Fortaleza (Souza Minayo, quoted in Lucchini, 1998). A 1991 study suggested that girls comprised between 3 and 30 per cent of the population of most street-living children throughout the world (Barker, 1991). Nevertheless, this relatively small population contains some of the most vulnerable youngsters in the world.

Why, then, is it that out of the mass of urban poor, some girls come to live on the streets? The most frequently cited push factor in these case studies is conflict with, or sexual harassment from, a stepfather, mother's common-law husband, or other male family-member, in the onset of adolescence, usually followed by rejection by the mother. But there are also other reasons; 'Passage House' in Recife, Brazil, carried out a census of street girls, and found 1,015 girls living on the streets or in brothels (their age distribution was: 47 per cent aged between 17 and 20, 36 per cent aged between 12 and 16, 15 per cent were aged between 6 and 11, and 2 per cent aged under 6). The majority of these girls left home because of fights, bad treatment or sexual abuse in their homes but some left because they wanted to earn their own money (Casa de Passagem, 1997).

Street life is not a static condition, and both girls and boys may move from neighbours' houses to street to institution in order to satisfy their physical and emotional needs. However, there is some evidence to show

that once girls leave home the rupture is more permanent and definitive than for boys, primarily because a girl's departure is most frequently because of sexual harassment or physical violence within their home (Table 1) or unwanted pregnancy. Some research suggests that the rupture with a primary care-giver – mother or other close family member – has especially severe consequences for girls (Gilligan, 1982; Apketar, 1997) possibly because the socialization patterns of young women are much more dependent on this primary relationship. While both boys and girls suffer when a primary relationship is broken, street boys show more resilience; programme reports from Kenya, Senegal, Bolivia, Brazil and Guatemala report that girls display more psychological damage – probably because of the combined effect of sexual abuse and rupture of the family – than boys do. Whatever the case, there is compelling evidence that girls and boys display gender-differentiated reactions that need to be given greater attention in our programmes.

While girls seem to have been spared the level of paramilitary violence inflicted on street boys in Brazil, one highly respected pioneer of work with street girls describes the experience of many girls as 'psychological death' (Vasconcelos, 1991) which finds its expression in violent behaviour, depression, withdrawal, and self-mutilation. This is borne out by reports from Guatemala, Bolivia and the USA.

There is increasing awareness that interventions that work for boys are not necessarily successful in meeting the needs of street girls.

However, 'non-normative' sexual behaviour is not necessarily sex work; a girl who is sexually available to boys in a gang, or who trades sex for food and shelter, may be motivated by the need for security, identity, and affection rather than money. Understanding the meaning of a particular behaviour or action is essential to helping a girl identify and choose other ways of having her needs met.

> *'The identification of girls who are on the street with sex work makes them less visible to people who are unfamiliar to the street world . . . they are classified in a category which is not that of street boys . . . the marginal girl and the delinquent girls are rapidly associated with sexuality and with the ghosts and prohibitions that accompany this. In boys, sexuality appears natural; . . . by contrast, female sexuality is seen as a potential danger.'*
> (Lucchini, 1998)

Aside from mental-health problems, street girls face numerous health hazards: respiratory infections, skin diseases, and the risks associated with unwanted pregnancies, abortion, sexually transmitted diseases, HIV and AIDS. Although both boys and girls use a variety of solvents, narcotics and drugs (to blunt hunger, for 'Dutch courage', or as a way of reinforcing group identity), research in Rio and Montevideo suggests that girls are

Table 1: Street and working girls: comparison of selected studies 1987–1998

Country	Reason on street	Problems encountered on street	Health problems	Work/sources of income	Sexual abuse in home	N	Education/school	Family background	Background	Age range	Source
Guatemala (Greater City)	61% Abuse in home 31% Peer influence 13% Sexual abuse	67% Drug abuse 55% Prostitution 48% Delinquency 68% Police abuse	27% Pregnancy 55% Hospitalized 48% Delinquency 68% Police abuse	36% Prostitution 36% Theft 16% Begging	27%	75	75% Have attended	56% Maintain relationship with family 11% Sleep at home	Majority living on street or in brothels	8–18	Hogar Mujercitas, 1991
Bolivia (La Paz)	49% Abuse or kicked out of home 15% Attractions of the street	Sexual abuse, prostitution, violence (among girls themselves)	100% had STD 72% Pregnancy			35		Family disintegration cited	All living on street	13–18	Fundacion San Gabriel, 1991
Brazil (Guiania)	53% Ran away from home 16% For theft (in institution)			Washing clothes, sewing, food preparation, domestic work		428	31% Street girls have no education	Parents usually itinerant workers	Adolescent women in government detention centres	18–19	Childhope, 1988
Bolivia (Cochabaoba)	21% Abuse in the home 20% Perceived the street as better than home 20% Poverty		12% Had given birth 65% Received no medical care	20% Domestic work 20% Street vendor 10% Water flowers in cemetery		98	66% Left school 33% Continue to study	23% Intact family, 21% Female headed household	56% have left home; rest living at home	6–18	UNICEF, Save the Children, Canada et al., 1991
Bolivia (La Paz)				49% Street vendor 39% Domestic work		77	32% Street vendors still in school 20% Domestic workers still in school	29% Intact families, 31% Female headed household	Mix of girls working on streets, living on streets and in government institutions	6–19	UNICEF, Save the Children, 1991
Bolivia (Santa Cruz)	24% Abuse in home 20% Poverty 8% Pregnancy		48% Pregnancy 29% Accidents	39% Domestic work 29% Vendor		75	8% Studying full-time		20% Lived with family, others lived on street	8–18	UNICEF, Save the Children, Canada 1991

	Abuse	Abuse by boyfriends Police harassment	Pregnancy STD's	Street vending Prostitution		Of those living on the street, only 24% still attended school	Family disintegration cited			
Philippines (Manila)	Unstable families				74			72% In care of NGO, rest on street	9–18	Childhope, 1989
Costa Rica (San Jose)	46% Hunger 35% Need to help with household expenses 19% To cover their own expenses	84% Sexual abuse 40% Verbal assaults 30% Physical violence 46% Political/legal problems	29% Intestinal disorders 34% Respiratory infections	50% Street vendor 38% Begging 12% Prostitution	56	34% Dropped out of school	46% Female headed household	32% Lived outside home 68% Lived at home	8–17	Trequer and Carro, 1998
Colombia (Bogota)	Girls 9–10 100% Violence in home Girls 11–20 51% Family violence 20% Lack of family income		25% Never received medical attention	100% Prostitution	14,211			Study of 14,211 women in prostitution 77% in brothels, 23% on street	9	
Brazil (Rio de Janeiro)	Abuse in home, sexual abuse, poverty		Pregnancy	79% Studying only 11% Working (6% Domestic work) 7% Study and Work	661		Family disintegration, weak family ties	Low income girls in favelas, 23 in-depth interviews with street girls	7–18	Childhope, 1988
Senegal (Dakar)	33% Abuse in home 33% Poverty in home	Abuse by police, drug abuse, lack of place to store any money	Pregnancy, STD's, poor nutrition	85% Prostitution	12	70% Not in school	80% from 'broken' families, 98% visit mothers once a week	In-depth interviews with 12 street girls	Not spec.	ENDA, 1987
Nicaragua	Family break-up, sexual abuse, pregnancy	Drug use, lack of sleep, sexual abuse	27% Pregnancy 21% STD's	32% Street vendor 35% Prostitution 21% Domestic work 12% Begging or stealing	35 85		Majority maintain family ties	52 worked on streets, 33 lived on streets	10–18	Childhope, 1989
India (Bombay)			43% Iron deficiency (anemia) Dental problems, respiratory illnesses, gastro-intestinal disorders		438	32% Work and Study 38% Study only 31% Work only	All living at home	Survey of adolescent girls in 10 urban slums	9–18	Pride, 1991

more likely to use substances that meet their emotional, rather than social or recreational, needs. Street girls interviewed in this survey report nearly universally that they lack a place to turn for healthcare and often receive second-rate treatment by healthcare providers unless they are accompanied by staff from a programme.

Urban girls at work

> *'The working female child, by contrast, works twice as hard as her male counterpart. As well as working outside the home in income-generating activities, she is expected to contribute to the maintenance of the family by assisting her mother and, in many cases, replacing her in the draining domestic tasks which must be performed on a daily basis . . .'*
> (Bunster and Chaney, *quoted in* Sellers, 1985)

> *'Why should I send my daughter to school? Who then is going to look after the babies, fetch water, clean and cook when I go to the market to sell my vegetables? Who is going to help me dig, weed and harvest?*
> (A Nigerian mother, *quoted in* NGO Action for Children Newsletter, UNICEF, July–September, 1995)

A double bind

Around the world girls work in domestic service, on the streets, in factories, in home-based industries, or in small workshops doing everything from rag-picking to basket-weaving, street vending to food preparation, book-binding to tailoring. With a few exceptions – such as young women working in garment factories – this work nearly always takes place as part of the urban, informal sector.

It is difficult to get an accurate picture of the breakdown between the work of boys and girls, but there are some figures available. The 1981 Indian census, for example, showed that 5.5 million out of 13.6 million urban working children were female (Weiner, 1991). A 1990 household survey in four of the major metropolitan centres of Colombia showed that 7.7 per cent of young women aged between 12 and 19 were working, versus 6.5 per cent of young men (Rico de Alonso, 1991). In Bolivia, one study estimated that 30 per cent of the country's 30,000 street and working children (including both those who live and work on the street) are girls (Fundación San Gabriel, 1991). Girls who work on the street while living at home, work primarily as street vendors, while others work in cemeteries watering flowers. While girls in Bolivia were previously kept in the home, the study concludes that recent economic crisis has forced more girls to the streets to work.

Child workers of both sexes often suffer disadvantages in schooling, abuses at work, and low wages. However, the situation of working girls carries added burdens since they face the same double working-day as their

mothers, combining wage labour with domestic chores. While boys may have time for education around their workday, girls have little time left over after work and housework. As less value is placed on the education of girls, they often begin work at an earlier age. Chores in the home often begin as soon as the girls are able to understand the tasks. In general, girls started working earlier than boys within their homes.

In most cases, the work chosen by girls is based largely on the work of their mothers. In Lagos, Nigeria, for example, street trading is a female-dominated activity. Men and boys who engage in street trading regard it as temporary employment, while girls know that it will be their future job (Oloko, 1991). In a sense, female jobs often tend to be 'ghettoized' and remuneration and status are low while hours are long. In industries and occupations that are predominantly female, particular health risks are evident. The matchbox industry in Sivakasi, India, for example, employs 45,000 children below the age of 15 of whom an estimated three-quarters are girls (Weiner, 1991). The girls are forced to remain seated on the floor for long periods of time without being allowed to use the toilet. Bladder infections and kidney damage are a common result of this maltreatment.

In sum, the fate of working girls is to follow their mothers into low-status, low-pay occupations. Their limited schooling combined with lack of entry points to the wider labour market means that they have difficulty securing a better future.

Domestic work

> *'When she is out of public sight, she is out of mind. Devalued as a child, denied equal access to education and often devoid of skills, she carries into her womanhood all the accumulated burdens of her past.'*
> (Burra, 1989)

> *'Cristina was 13 years old when she was forced to work as a househelp in Manila to raise her younger sisters and brothers. They are orphans already. Paid only P250.00 a month (US$9.60) she works from 4.30 in the morning until 10.30 in the evening, seven days a week. Despite this almost slave treatment she opted to stay for 10 years with her employer.'*
> (TABAK-Philippines, 1995)

Girls in domestic work are often overlooked in discussions of at-risk girls and young women. They are kept out of sight behind their employers' doors. Yet the numbers suggest that domestic work outside their home may be the most common form of work for urban-based girls. Available data, which probably underestimates the true extent of domestic work, shows a large population of young women working as domestics. To give an indication of the size of the domestic working population, studies in Indonesia estimate that there are around 400,000 child domestic workers in Jakarta and up to five million in Indonesia as a whole (ILO, 1996). Similarly in Sri

Lanka there are about 500,000 (ILO, 1996). In Venezuela 60 per cent of the girls working between the ages of 10 and 14 years of age are employed as domestic workers (ILO, 1996).

The majority of child domestic workers tend to be between 12 and 17 years old, but some surveys have identified children as young as 5 or 6 years old. For example, a Bangladesh survey of child domestic workers found that 38 per cent were 11 to 13 years old, and nearly 24 per cent were 5 to 10 years old. Other surveys found that 16 per cent of child domestic workers were 10 years old or less in Togo (ILO, 1996); 26 per cent were less than 10 years old in Venezuela (ibid.)

There are three categories of domestic workers: live-in workers, day help, and those who carry out particular tasks such as washing clothes. Live-in workers are in the most danger because of their limited contact with the outside world. They are often brought from the countryside as young girls and have little or no knowledge of city life. They are therefore likely to be much more docile and submissive. They have little free time, and are often prevented from leaving the house.

Day workers typically have more freedom. However, the price they pay for this is often a lower standard of living than the live-in. They get even more limited access to the benefits of the employer's large home, and must pay room and board for themselves and their family out of their meagre earnings. Similarly, domestic workers who carry out particular tasks probably have the least job security and the lowest pay of the three groups. Such workers are often the secondary maids.

'When I look at children enjoying themselves with their family members, I long to be with my family'
(Jagadeeswari, 13 *quoted in* Arunodhaya and Anti-slavery, 1999)

The exploitation of domestics goes unrecognized in most countries because it is both widespread and, at the same time, more isolated than any other form of child labour. This isolation is reinforced by cultural boundaries: in many cases the girls, who are cut off from their family and rural culture, speak a different dialect and find it difficult to communicate with the few contacts they have. Data from Peru show that in 1990 two-thirds of domestic workers were recent immigrants to the city from the sierra region (Radda Barnen, 1992). In Senegal, girls migrate from rural areas – often from other tribal groups – to the city to work in domestic work during the dry season; they are thus largely isolated from their family and village for months at a time (site visit, Enda-Senegal).

Domestics may also have great difficulty in forming and maintaining a family, and are often among the few women in developing countries without children or relationships. Girls who live in may be prevented from having boyfriends because of the supposed bad influence on the employer's children. In many cases, domestics are 'treated as part of the employer's

family' because of the many years they live in the family home and the fact that they bring up the employer's children. Although this bond may mitigate feelings of isolation, some authors have argued that helping domestics to see that they should have their own families, and that they are in a work relationship, is the first step in securing their freedom (Chaney and Castro, 1989).

Domestics, particularly young ones, are also at high risk of sexual abuse. A 1987 study of 100 families in Peru that employed housegirls found that 60 per cent of the adolescent males in the household had their first sexual experience with the housegirl (Radda Barnen, 1992). Indeed, in Latin America, some researchers have alleged that the mass media encourages the sexual exploitation of domestics by portraying them as promiscuous and at the disposal of young men in the household. In Brazil and Colombia, women in sex work report that they turned to sex work after being sexually abused by employers in houses where they worked.

Young domestics also encounter difficulties in continuing their education. In Argentina, for example, 55 per cent of all domestic workers of all ages had no or incomplete primary school-level education – in a country with high school-enrolment rates for women. Similarly, a study in Kenya with 32 young women involved in domestic work found that on average they have been enrolled in schools for five or six years (Onyango and Orwa, 1991). For live-in domestic workers, the possibility of continuing schooling while working is even more difficult. The contradiction of a young domestic preparing the school lunch for the child of the employer, while she herself is not given access to education, is common.

In addition to difficult work conditions, domestic work is generally not recognized socially and economically. The workers have little status, and receive low pay for long hours of work, which they often cannot control. In some cases, the girls are not paid at all but merely work for room and board. In other cases, there are promises of pay but after years of work they leave the house empty-handed (Blagbrough, 1995).

Countries have been extremely slow to enact legislation to protect adult domestic workers, let alone children. Domestic work carries few regulations about hours of work, and generally no access to social-security benefits. In the few countries where legislation does exist, employers find it easy to avoid as the women themselves are unaware of their rights (Weinert, 1991). In Peru, where legislation does exist, only 15 per cent of domestic workers of all ages are registered with the social-security programme. In a few countries, NGOs have been successful in enacting legislation for domestic workers, yet much of it is unenforced. This question of enforcement is particularly difficult for live-in maids. Many countries have laws, for example, which call for 'sanctity of the home', meaning that

government officials have difficulty inspecting the work conditions of a live-in. This issue of entering into employers' homes is also an obstacle to carrying out research on the situation of live-in maids (Radda Barnen, 1992).

Projects for assisting child domestic workers have typically been of two types:

o Organising them to demand their legal rights or to gain knowledge of rights
o Improving their skills as domestics to professionalize the industry.

Both types focus on making domestic labour socially and economically recognized. A third type of project has been that of providing basic education or literacy for domestics, typically at night or at weekends. However, projects trying to organize child domestic workers have encountered serious difficulties. The live-in is difficult to find and hard to access. The long work hours of all types of maids present problems of organization. In the Philippines, for example, efforts to form support groups among domestics in Cebu failed because the women could only leave the houses of their employers when the employers were out. Thus, they were never able to organize a common meeting time. Employers often resist efforts to improve the conditions of their domestics. Submission and lack of knowledge are important ingredients in maintaining long hours and low pay. The issue of being able to leave the house of their employers has also been an obstacle to programmes offering education and literacy (see UNICEF Innocenti Digest 5: Child Domestic Workers, 1999).

Projects to professionalize domestics range from those with conservative backgrounds which simply encourage maids to work harder and be obedient, to those that seek to improve skills and hence the pay and working conditions that a domestic worker can demand. The best of such projects also offer job placement and monitoring after training, as is the case of the case study of the Child Welfare Society of Kenya project described in Chapter 2. Some organizations have also formed agencies of domestics, guaranteeing quality service and honesty, in exchange for job security, decent wages, and controlled hours. Domestics with additional training may also secure work in hotels and restaurants where the pay and working conditions are more easily monitored.

In many developing countries, women have even more limited access to jobs than men. Thus, domestic service may be one of the few legal opportunities available. This has been the basic rationale for raising the professional status and legislation relating to domestic work. However, domestic work is unlikely ever to be a well paid job with upward mobility and adequate social recognition. In the best of situations, programmes should work to ensure that domestic work is a temporary source of income while young women seek other possibilities. In the long term, we must search out

non-traditional forms of work for young women and provide them with the training necessary.

Commercial sexual exploitation

> 'We have the same place that bums do in society. No one wants to know us or be seen with us. We're damned.'
> (Commercially sexually exploited girl, Senegal)

> 'For many years now, my life has been a series of hits and misses. I have had many kinds of customers, foreigners and Filipinos. I tried suicide but it didn't work so I turned to drugs. I don't know about tomorrow. I want to die before my next birthday.'
> (Sex worker, the Philippines, *quoted in* O'Grady, 1992)

> 'Sex is a natural thing here. Everyone's at it, fathers do it with their daughters, brothers do it with their sisters, they don't care . . . they're like animals . . . by the time a girl is ten years old, she's had more experience than an American or Irish woman will have in their whole life. Girls learn it's the way to keep a man happy – it's a natural way to please men.'
> (Tourist interviewed by Julia O'Connell Davidson, 1996)

Over the last ten years, increasing attention has been drawn to the sexual abuse of children and adolescents by adults. The 1996 Stockholm Conference on the Commercial Sexual Exploitation of Children focused in particular on the commercial exploitation of children through sex, pornography and trafficking, and led to a greater commitment to their elimination. In spite of this, there has been little systematic study of the issue, and the figures that do exist are often unreliable because of the clandestine nature of the issue and the difficulty in drawing boundaries between non-normative sexual activity (which may involve multiple partners and be dangerous), sexual abuse, commercial sexual exploitation, and sex work. A new feature of commercial exploitation is the wide availability of child pornography on the Internet.

The term 'Commercial Sexual Exploitation of Children' (CSEC) is used by ECPAT[1] to define the sexual exploitation of a child for remuneration in cash or kind, usually but not always organized by an intermediary (parent, family member, procurer, teacher, and so on).

Estimates of the number of girls and young women who experience commercial sexual exploitation can only give a tentative idea of the scale of the issue. According to a UNICEF survey in 1995, there were 10,000 to 15,000 sex workers in Phnom Penh, of whom a third were under 18 years

[1] End Child Prostitution, Child Pornography and the Trafficking of Children for Sexual Services.

old (UNICEF, 1995). In Colombia, the City of Bogota Chamber of Commerce released in 1994 the results of a study revealing that in the capital of the country there were between 5,000 and 7,000 sex workers under the age of 18, a third being under the age of 14 (cited in ECPAT, 1996). What emerges is a population relatively small in relation to peers from equally poor backgrounds, but one that experiences enormous danger and potential psychological and physical damage.

Patterns of CESC vary. In some cases, young women are encouraged by their families or common-law husbands to take on sex work. Other young women in Africa report a prevalent phenomenon of 'sugar daddies' – older men who offer favours such as a meal, or a ride to school in exchange for sexual favours (Barker and Rich, 1992). In addition, with the massive spread of AIDS in Africa and Asia, there is circumstantial evidence that men are seeking younger partners in the belief that the younger they are, the less likely they are to have been infected by HIV. This pattern of seeking younger women is also occurring in parts of Asia (Barker, 1992).

In the US and Europe as well, a significant percentage of homeless and runaway youth are the subject of commercial sexual exploitation. In interviews with 98 street youths in New York City (of whom 47 per cent were females), 70 per cent were involved in sex work (correspondence, Victims Services Agency, 1992). Girls subjected to commercial sexual exploitation often exhibit severe depression and suicidal tendencies. Young male victims are likely to have similar problems (O'Grady, 1992; World Vision, 1996).

HIV infection is an extremely serious risk factor for victims of commercial sexual exploitation, particularly the young. Sexual intercourse between a child and an adult is more likely to transmit HIV because the child's tissue is particularly vulnerable to ruptures and tears and consequent bleeding; in addition, repeated acts prevent healing and leave open sores (O'Grady, 1992). In a 1991 rescue operation conducted by a Thai NGO, the Centre for the Protection of Children's Rights, all of the 20 girls rescued eventually tested HIV-positive (CPCR, 1992). In focus-group discussions with 20 street girls in Nairobi, Kenya, they reported not being able to afford condoms and that they only used them when the clients provided them (Barker and Mbogori, 1992).

Even when street girls can afford condoms, the difficulty of persuading the client to use the condom, together with the high number of clients received by these youngsters, makes condom use very difficult.

'When I was seven years old I went to live in a brothel. The men there liked really 'new' girls. The men liked it when I danced on the tables . . . I lost myself when I was very young.'
(16-year-old girl involved in sex work, Brazil, *quoted in* Vasconcelos, 1989)

In most industrialized countries the sexual exploitation of children is illegal and subject to heavy penalties that are generally strictly enforced. In developing countries, legislation is often less stringent and even when it exists, is seldom enforced among low-income sectors of society. Police and local authorities lack either the will or the resources necessary for enforcement. Child abusers from industrialized countries have taken advantage of these legal deficiencies by taking sex tours to gain access to children and youth in developing countries, or by taking advantage of easy access to sex while on a business or holiday trip. Sex tourism was first noticed and documented in Asia – primarily Thailand, the Philippines, Sri Lanka, and Taiwan – but there is evidence that it has become more common in parts of Latin America and Eastern Europe (report by ECPAT at the Stockholm Conference 1996; investigations by ECPAT Sweden). Youth involved in sex tourism, most commonly female, work both in bars and the streets to service the foreign tourists and businessmen. There is strong anecdotal evidence that the prostitution of boys in the Thai village of Paksangyan was catalysed during the 12 months in which the film crew of *Apocalypse Now* was stationed in the region.

> *'Child sex tourism often involves cultural misunderstandings: child abusers are convinced that what they do cannot be prejudicial to their victims, and justify themselves by saying that they are economically helping the children and their families.'*
> (ECPAT UK Student Pack, p. 15, 1997)

While steps are being taken to eradicate sex tourism in many countries, this represents only a small component of the sex industry: most sex work caters to local users. Even in areas such as the Philippines' Olangapo Bay, where child prostitution is strongly linked to the presence of foreign navy personnel and tourists, the majority of users are local (Jubilee Campaign, 1992). In Thailand, for example, 75 per cent of men report having had sex with a prostitute and 48 per cent their first sexual encounter with one (Pynn, 1992).

Pornography and trafficking of children are two other major and interconnected problems. The organization, Anti-Slavery has extensively documented the illegal and clandestine traffic of human beings across borders involving bribery, abduction, false identification, sham marriages and adoptions; notoriously from Burma, China, Laos into Thailand, and from the hill country of north Thailand into its cities (Skrobanek et al., 1997). It is a sad fact that some parents, in some villages, actually sell their daughters into brothel prostitution – which underlines the particularly low value placed on girls in the places where it occurs. The sale of children into prostitution is likely to be an extension of other profoundly entrenched forms of oppression. However, it is much more common for largely illiterate adults to be deceived into thinking that children are being placed in

domestic work or other jobs. In Brazil, an investigative report carried out in 1992 by one of Brazil's most influential newspapers in conjunction with UNICEF found trafficking of young girls in cities in the Amazon region of the country. Many of the girls ended up in brothels where they are sold off, bringing as much as US$400 to the seller. The brothel owners used debts owed for housing and food as a way to prevent the girls from escaping (Folha de Sao Paulo (newspaper), 1992).

In cases where girls have access to earnings from sex work, it is much more difficult to enable them to leave. In Dakar, Senegal, adolescent girls involved in sex work report that they can earn between US$7 and US$90 per day in sex work, compared with street girls who beg who may earn between US$7 and US$17 per day (Wright, 1987). Under these conditions, programmes often have limited success. One programme in Thailand working with women involved in sex work found that approximately seven out of ten women who had taken part in a vocational training programme returned to sex work because there was no other work available in their communities (Davies, 1987). Vocational training programmes in Chile and Colombia for young women involved in sex work, also report high rates of reversion of young women trained to work in the garment industry. When the factories are forced to cut back for seasonal fluctuations in orders, the young women return to prostitution (personal correspondence and interviews, Chile and Colombia, 1991).

In opening this section we emphasized the importance of using the term 'commercial sexual exploitation' over that of prostitution. The importance of doing so is frequently emphasized by NGOs working with young women because it acts as a means of highlighting the injustice of stigmatizing young women for their condition. Unfortunately, however, some NGOs working with young women refuse to accept girls who have been involved in sex work for fear of 'infecting' the rest of the girls with deviant behaviour. Similarly, in the battle against AIDS, the concern is too often for the safety of the customer rather than the women. As Chantawipa Apisuk, of the Thai NGO Empower has said, '[we must help women to] . . . protect themselves. It is not a question of not giving AIDS to men!' (Seabrook, 1992).

In most cases, efforts to assist sexually exploited girls have almost always focused on rehabilitation of the victim and not on prevention by addressing the demand for sex work. Unfortunately, only occasionally have efforts been directed toward the poverty, cultural practices and gender inequities that push youngsters into this condition, or to one root cause of the problem – the customer whose involvement is both voluntary and usurious. Essential, but at present rarely used, preventative measures could include support to families of at-risk children (particularly the children of adult sex workers), and sexual-awareness education for both boys and girls.

Teenage mothers

> '... for some adolescent girls having a child can serve as an organizing and maturing experience, a psychological catalyst for pulling themselves together and getting on track.'
>
> (Musick, 1993)

> 'I named my son John Lennon. Why? Because he imagined a better place.'
>
> (Teenage mother, 17, Brazil)

> 'He changed my life. He really made me feel good. I was hooked on drugs and always on the streets. So my son is really something special ... Now I have someone to depend on me.'
>
> (Teenage mother, USA *in* Musick, 1992)

Worldwide, adolescent women aged between 15 and 19 have more than 14 million births each year; more than 80 per cent of them are in developing countries (Alan Guttmacher Institute, 1998). The true rate of pregnancy for adolescent women is unknown because of a lack of statistics on abortion and miscarriage, but is undoubtedly higher. Some 12 to 28 per cent of young women in Latin America and the Caribbean give birth before the age of 18 and this ranges between 3 and 27 per cent in the countries of North Africa and the Middle East (ibid.). In most Asian countries, fewer than 20 per cent of women have their first child before the age of 18, although about 30 per cent in India and almost 50 per cent in Bangladesh do (ibid.).

In traditional societies and today in many rural areas, early childbearing follows adolescent marriage – a trend which continues today in much of rural Africa, Asia, and limited areas of Latin America. However, with wide-scale urbanization in developing countries, increasing school enrolment for girls, and higher ages at marriage in most countries, early childbearing is increasingly taking place outside marriage. In general, urbanization has also led to a breakdown of traditional rites of passage for adolescents. In rural areas, youth typically passed from childhood to adulthood with clearly prescribed rites and behaviour regarding sexuality. Adolescence as a social construct did not exist; young people typically passed from childhood to adulthood and early marriage. In urban areas, on the other hand, marriage typically comes later and higher nutrition leads to lower ages at menarche. These trends, coupled with increased school enrolment, have led to a growing gap between the age of menarche and the age of marriage.

More than half of all adolescent births in France, Germany, Great Britain and the United States are to women who are unmarried (Table 2). This is part of a general trend toward higher levels of childbearing among single women, not just adolescents. However, adolescent unmarried mothers

invariably suffer emotional and financial strain in having to cope with the stress of raising a child without support and possibly without her family (Alan Guttmacher Institute, 1998). There is ample evidence to show that much of this early childbearing is unplanned. In Latin America and the Caribbean it ranges from one-quarter of all adolescent births in Guatemala to one-half in Peru. In sub-Saharan Africa the rate of unplanned pregnancies varies widely, ranging from a relatively low 11 to 13 per cent in Niger and Nigeria to half or more of all adolescent births in Botswana, Ghana, Kenya, Namibia and Zimbabwe (Alan Guttmacher Institute, 1998). Alarming rates of clandestine abortion among adolescent women attest to the issue of unwanted pregnancies. Estimates of backstreet abortions to women of all ages in developing countries range from 10 million to 22 million; extrapolating from those figures, a recent study by the US-based NGO called Advocates for Youth estimates that adolescent women in developing countries may have between 1 million and 4.4 million abortions annually (Hirsch and Barker, 1992). Understandably, there is quite a wide margin in the estimates because of the difficulty in access to such covert information.

'The [young women] said they knew classmates who had procured backroom abortions or had self-induced abortions. They told of a classmate who took an overdose of sleeping pills to try to induce an abortion, another who took quinine, another who drank bleach, and one who cut herself with a razor blade. Three of the four young women died in their attempts.'

(Interviews with peer teen counsellors, Kenya *in* Barker and Rich, 1992)

Data from 27 studies in developing countries, primarily hospital-based and in urban areas, found that adolescent women under age 20 accounted for approximately 60 per cent of women presenting with abortion-related complications. While the exact number of deaths attributable to these complications is unclear, evidence suggests that adolescent women comprise a significant percentage of the estimated 100,000–200,000 deaths each year that result from abortion-related complications in developing countries (Hirsch and Barker, 1992).

Adolescent women who carry their pregnancies to term face a number of medical risks associated with childbirth: women under 20 years old tend to suffer more pregnancy and delivery complications (including toxaemia, iron-deficiency anaemia, premature delivery, prolonged labour, hypertensive disorders of pregnancy, cervical trauma, pre-eclampsia, and death) than do women who bear children aged 20 or later. In addition, babies born to teenage mothers are more likely to be of low birth-weight, and their risk of death during the first year of life is 30 per cent higher than those born to physically mature women (Alan Guttmacher Institute, 1998; WHO, 1989).

However, much of the current research demonstrates that adequate prenatal care for pregnant teenage mothers can considerably reduce the risk of maternal and child mortality. Provided young women are well nourished and have access to prenatal care, the health risk to young mothers and their offspring is virtually equal to that of mothers aged over 20. Furthermore, most research now suggests that the health risk associated with childbearing for adolescent mothers over 15 years is more a factor of socio-economic status and social attitudes toward adolescent sexuality and adolescent childbearing than a biological factor related to age (WHO, 1989).

Support for pre- and postnatal care, however, is often non-existent for low-income adolescent mothers. Due to the shame associated with adolescent pregnancy, young women are often slow to acknowledge their condition and slow to seek prenatal care if it happens to be available. One study from Colombia, for example, found that a majority of 10,000 adolescent mothers studied did not have strong support either from their family or their mate. The majority of the young women interviewed were from low-income families and were malnourished (Contreras, 1990).

Although there are a large number of unwanted pregnancies, it is clear that many adolescent pregnancies are greatly desired: a child represents entrance into womanhood and status for young women who would otherwise have none; and pregnancy, even for a poor and isolated girl with no financial security, represents a rational choice for addressing feelings of isolation and poor self-esteem (Barker and Musick, 1994). But in a difficult urban environment, adolescent childbearing hinders possibilities for educational and vocational attainment (see Box 4). In at least nine sub-Saharan African countries, girls are temporarily or permanently expelled from school if they become pregnant, although no punitive action is taken against boys who become fathers. In Kenya, some 10,000 girls leave school annually due to an unplanned pregnancy (Ngwana and Akwi-Ogojo, 1996).

In other settings, pregnancy leads to school dropouts because teenage mothers need to work to support themselves and their child. In some countries, there is also social stigmatization associated with out-of-wedlock pregnancy. In Rwanda, for example, a study of 510 teenage mothers found that 10 per cent were disowned by their families (Barker, 1992). Addressing unwanted pregnancies among teenagers means dealing with thorny issues related to sex education and family-planning distribution to unmarried adolescent women – an extremely sensitive issue in many countries. While research shows that the provision of sex education and contraceptive services to adolescents does not encourage sexual activity (Grunsheit and Kippax, undated), the issue remains controversial. For young women who have valid psychological reasons for wanting a child, preventing early pregnancies requires the offering of meaningful

> **Box 4: Research in Tanzania**
>
> o In Tanzania (Mwanza region) a research project carried out by Kuleana Centre for Children's Rights involving 740 pregnant schoolgirls in both urban and rural areas (including 20 who had been expelled from school due to pregnancy) found that:
>
> o when 'discovered', pregnant girls have little say in determining their schooling as decisions are made by parents and teachers
> o virtually all expelled girls interviewed in the study expressed a strong desire to return to school but felt that no adult was willing to listen to them
> o the men who made the girls pregnant (who were often adults, including teachers) were rarely held responsible for their actions
> o girls in Grades 5 and 6 and girls from poor families were the most affected and least likely to be able to terminate pregnancy or continue their education at other schools after childbirth.
>
> *Source*: Kuleana Annual Report, 1996

alternatives to childbearing. In any case, there is much to be done to reach the point where low-income young women in developing countries have a choice over when to start their childbearing.

As mentioned earlier, daughters of teenage mothers are more likely to be teenage mothers themselves. In the Philippines, interviews with 108 teenage mothers found that 60 per cent of their own mothers were under 20 at the time of their first birth (Palatto-Corpus, 1991). Similarly, in the USA daughters of adolescent girls are between one-third and two times as likely to become pregnant while teenagers than those born to older women.

For girls who carry pregnancies to term, there is a need to provide intensive social services. Young women need help dealing with their own adolescent development while at the same time learning to be a parent. Intensive day-care and parent training programmes are often needed if the child is to have opportunities for healthy development.

Identifying needs and programme responses

Urban girls and adolescent women need the opportunity and suitable conditions in which to build new relationships that are both healing and enabling. As mentioned earlier, much self-destructive behaviour in at-risk young women is a direct response to the break up or troubled nature of their primary relationship with their mother or family. Therefore, the

Table 2: Births to adolescent mothers worldwide (selected countries)

Country	% of women 20–24 who gave birth by age of 18	% of women 20–24 who gave birth by age 20	% of adolescent births to unmarried women	% adolescent births that are unplanned
Zambia (1992)	23	47	29	50
Kenya (1993)	28	52	44	57
Egypt (1992)	15	29	Unavailable	16
India (1992–1993)	28	49	Unavailable	16
Philippines (1993)	8	21	Unavailable	44
Thailand (1987)	9	24	Unavailable	32
Brazil (1996)	16	32	29	49
Colombia (1995)	18	36	31	44
Great Britain (1991)	6	15	87	Unavailable
USA (1995)	9	22	62	66

Source: The Alan Guttmacher Institute (1998)

construction of a genuine and supportive relationship between girls and educators should be one of the first steps of all programmes aiming to assist girls and young women at risk. Some girls and young women do need great assistance in finding positive substitutes for negative behaviour such as involvement in destructive relationships and self-mutilation. They need to gain a sense of security and confidence in order to overcome their fear of moving from the known behaviour to an unknown one. A common and, frequently successful, strategy is group therapy including music, dance and drama. These groups are made up of other individuals with whom they can identify, and to whom they become attached, and are normally places were they can express their feelings in ways which are non-threatening, both to themselves and their peers. In these groups they may find solidarity and support to help them change their lives.

Another crucial step to assisting girls and young women at risk is helping them to identify at least one thing that they can do well that will eventually allow for economic independence. Doing meaningful work will confer a sense of pride and competence. Basic literacy is generally a prerequisite for most activities in the world of work in urban areas.

Conclusions
We have identified a several specific areas that seem to encompass the most important needs of girls and young women and which will be discussed in the next chapters. These are as follows.

Employment/income generation
Most urban vulnerable young women work in areas with little opportunity for advancement and with low pay. Programmes must improve their ability to provide for themselves and their families by breaking down barriers which relegate them to stereotyped occupations with little remuneration. Programmes must seek to provide young women with training in non sex-stereotyped skills that provide dignified work.

Education
Education has tremendous spin-offs both for the health of young women and their children – and for building self-esteem. Given high school dropout rates for this population, education (whether formal or non-formal) must be a cornerstone of any programme working with young women.

Mental-health services
Mental-health services are particularly important for girls and young women in especially difficult circumstances. Before any educational or social service programme will be of use, a first step in assisting these women should be to address underlying self-esteem problems.

Physical health
Most vulnerable urban young women have health problems that started in childhood. Addressing these health needs, particularly during the adolescent growth spurt, has tremendous ramifications for future safe motherhood and the survival of children. There must be some emphasis in teaching them how their body works (reproductive health) and how to take care of the body (nutrition as well as protection against STDs). Many girls need a safe place to stay – such as hostels – or a place they can visit during the day where they can meet others, get cheap and nutritious food and advice, and even leave their children while they work.

Culture
Because of urbanization – and in the case of domestic workers, isolation from their traditional culture or spiritual values – urban young women in difficult circumstances frequently need assistance in reconnecting with their roots.

Involving males
Gender issues must be seen from both ends of the spectrum in order to strike a necessary balance. Values learned in childhood – and reinforced in

adolescence – must be questioned in order to promote changes in both sexes' attitudes and behaviour. Therefore, opportunities must be created for boys and young men to review their values and attitudes, and also to learn about issues generally considered to be a female responsibility such as reproductive health, child rearing and so on.

Rights
As highlighted previously, the Convention on the Elimination of Discrimination Against Women (1979) and the Convention on the Rights of the Child (1989), and the Beijing Platform for Action (1995), provide important tools for advocates seeking change to protect the rights of children and urban young women in difficult circumstances and to change public attitudes. Frequently, young women are unaware of their rights, or unable to protect themselves from infringements of these rights.

The chapters that follow deal with each of the major topics just described. A number of important programmes in developing countries and elsewhere have worked with young women in providing one or more of these services. Chapters 2–6 describe in detail several examples of successful projects. Chapter 7 looks at how the types of strategy and work being carried out in various fields with boys and men can help to redress gender inequalities. And the last chapter presents some concluding remarks.

Each of Chapters 2–6 consists of:

o an introduction
o a major overview of a project or programme
o a case history of a young woman relevant to the topic of the chapter
o two shorter project descriptions
o a summary of the major lessons learned or elements of success of the projects described.

In selecting the projects, an effort was made to include programmes from a variety of cultural and geographical settings. As the programmes were analysed, the following set of questions was used:

o What is the goal of the programme?
o What is the target population and what problems do they face?
o What services are provided to young women?
o What are the elements of success?
o What are the results of the programme?
o How much does the programme cost to implement? (where such data were available)
o How is the programme connected to the family and community, including the government?

2. Income Generation and Vocational Training

'States Parties recognize the right of the child to be protected from economic exploitation and from performing any work that is likely to be hazardous or to interfere with the child's education, or to be harmful to the child's health or physical, mental, spiritual, moral or social development.'
(Article 32, Convention on the Rights of the Child)

'States Parties shall . . . make educational and vocational information and guidance available and accessible to all children'.
(Article 28, Convention on the Rights of the Child)

Introduction

GIRLS AND YOUNG women face many obstacles to finding well-paid employment that offers opportunities for advancement. These include:

o *gender-role stereotypes* that limit the kinds of jobs for which young women are considered appropriate
o *vocational training that tends to follow this stereotyping*, such as training in cooking, sewing and domestic chores
o *the need for day-care* for young women who have children
o *the difficulty of combining school, work outside the home, domestic work at home and vocational training.* Many young women find it difficult, if not impossible, to take time off from domestic work – for example, to participate in a vocational training programme.

Even when programmes succeed in training adolescent women in technical skills, these women often find it difficult to secure employment in economies with widespread under- and unemployment. Furthermore, young women may have technical skills, but lack the business skills to run their own enterprise. As a staff person with Tototo Industries, a vocational training programme for young women in Mombasa, Kenya, says:

> *'The hardest part we see is after the training. What do the girls do afterwards? We need an organization to help them just with setting up their businesses. It is too expensive for us to work with each one. We need a fund that would help them set up their own businesses and give them advice on how to manage their business.'*

That, in fact, is what Street Kids International (SKI) is doing in Zambia by

training and providing access to credit for impoverished young people. The provision of small loans to support the entrepreneurial dreams and ambitions of youth can be an effective means to helping them change their lives. However, the experience of SKI has shown that credit must be extended in association with other types of support that help participants develop critical life-skills as well as productive businesses.

In spite of the successful experience of SKI, it is generally acknowledged that micro-credit will not be the saviour of all those living in poverty. In some parts of the world, for example, Bogota, Colombia, many programmes working with low-income youth have all but abandoned the notion of micro-credit and small-business creation because they have concluded that in an era of large corporations and a global economy, for most of these young people micro-enterprises are an economic dead-end. In some settings in developing countries (but certainly not all), micro-enterprise development, in the informal sector in particular, has come to be seen as an area with extremely limited growth potential that provides little more than subsistence wages.

Those programmes that have succeeded in helping young women find employment mainly responded to a perceived need in the market-place or worked to create a demand in the market-place, as in the case of the Child Welfare Society of Kenya. Some programmes have also seen the need for sheltered work settings in which young women are allowed to sharpen and refine their skills so that they can truly compete in the job market.

In virtually every case, successful programmes working with urban young women in vocational training have tried to instil a sense of hope and self-confidence. In the words of a young woman training to be an auto mechanic with Undugu Society in Kenya: 'I have to work harder than men because I can't lift as much [weight] as they can. So I have to be technically better. But I can do it.'

Case study
Youth Skills Enterprise Initiative (YSEI), Street Kids International (SKI); Zambia

In 1995, the YWCA of Zambia, the Zambia Red Cross and Street Kids International embarked on a partnership programme to assist street and working youth to earn an income. The result was the Youth Skills Enterprise Initiative (YSEI) which integrates basic business-skills training and life-skills training and provides access to small loans. It aims to be a youth-centred, participatory process addressing practical economic needs as well as the broader social and health needs.

This programme is an innovative response to the increasing numbers of street and working children in Lusaka, Zambia. All the street children

participating in the programme return home either to their parents or extended family. Although small business training and credit programmes have become more commonplace for adults, very few organizations anywhere have adapted and directed such initiatives to those under the age of 20. In the absence of models to guide the development of YSEI, considerable time, effort and technical expertise has gone into both designing, reviewing and adapting this programme.

In Zambia's capital city of Lusaka an increasing number of young adolescent women are looking for safe ways to earn a livelihood. Only 19 per cent of secondary-school-aged girls attend classes due to insufficient numbers of spaces available and to an increasing preference to pay for sons' education over daughters' (UNICEF, 1997). Those who cannot attend school have their options limited for a lifetime. Many become single parents, thus increasing the urgency to find forms of support.

Nearly 70 per cent of Zambians lack access to basic needs, 45 per cent of children suffer from chronic malnutrition, and many more are threatened by the AIDS epidemic which poses a very serious health threat. (It is estimated that at the start of the twenty-first century that there will be 500,000 to 600,000 orphaned by AIDS (Futures Group, 1999).) Many of these children are looked after by their extended family members but as these support structures get stretched and the economy deteriorates, more children are finding themselves without safe places to stay.

YSEI is directed to vulnerable young men and women who have the following characteristics:

o aged 14 to 20 years
o currently out of school
o have a Grade 7 level of education or less
o live in sub-standard or unsafe conditions.

All participants of YSEI are out-of-school youth who are in this situation either because they got pregnant (and were therefore thrown out of school), they could not afford the school fees, or they failed their Grade 7 entrance exams and therefore could not go any further. They are all from very low-income families. Most have been born in Lusaka although their parents may have at one time lived in rural areas. Many participants only have one parent and some have no parents, and in many cases this is due to AIDS. Many of the girls who participate do not see any future for themselves prior to starting the YSEI programme. However, they soon become excited about the programme because, besides helping them to make money, it gives them a sense of what they can be. In a recent evaluation (1998) it was found that:

'Almost all can identify goals for themselves and for their businesses. The most common life goal was to acquire their own house, which was

followed by the desire to be a very successful business person. Fifteen per cent of those interviewed are determined to finish school and go on to higher education.'

(Ann Sutherland from Street Kids International, site visit May/June 1998)

YSEI has been a particularly successful catalyst in changing the lives of the adolescent women who make up approximately 65 per cent of the participants. Many of these have young babies and are themselves orphans, living with members of their extended families in very crowded conditions. Often their previous options to earn a livelihood had been limited to occasional sex work.

To date (1998), almost 200 youth have participated in YSEI and 125 of these have started their own micro-businesses. One hundred and fifty loans have been disbursed, averaging US$50 each. The project officers develop training schedules that respond to the training needs and the time-availability of the participants. There are normally two weeks of half-day training sessions and after the grant of the loan the youth recipients must participate in a weekly support meeting. From time to time they are invited to take part in a refresher course. The YSEI charges ten per cent interest on the loan which is repaid in instalments each week at the time of the meetings. They are also expected to invest ten per cent of their income in a savings account. The core training includes:

o group-building
o entrepreneurship and community economic development
o basic business skills: identifying demand; developing a business idea; costing and calculating profit; doing a feasibility study; preparing an investment plan; credit and savings management
o life-skills specific to enhancing one's business: communication skills; goal-setting (for business and life); teamwork; creative problem-solving; conflict resolution; negotiation; customer service
o awareness-raising of issues relevant to the life experiences of youth growing up on the street: HIV/AIDS awareness; substance abuse and decision-making about high-risk behaviour; gender awareness; STDs, sexuality, contraception; nutrition.

The first business chosen by many participants is petty trading which involves buying wholesale items and selling them in smaller quantities. Other enterprises have included food kiosks in the market place, small barbershops and salons, tailoring businesses, and raising poultry. Participants are encouraged to start very basic businesses and then to grow and diversify as they gain experience in business practices and in handling money.

There are similarities in how profits are spent. At first, this usually goes

to purchasing soaps, lotions, and second-hand clothes for the participants – and if they are mothers to the needs of their babies. Money then tends to flow to buying additional food for their households. Extra income is then used to pay for healthcare, school fees and uniforms, and occasionally for luxury items such as watches and cassette players. There have been cases of participants with tuberculosis who are now able to pay for medical check-ups, X-rays and medicine that were previously unattainable for them.

The development of personal skills and basic enterprise skills is recognized as being just as important as the distribution of credit in the creation and sustainability of this form of livelihood. It is also considered essential that awareness-raising about sexual health and human-rights issues as well as recreation activities be woven into the programme. The successes and failures have shaped the ongoing development of this YSEI and, in the process, much has been learned about supporting youth in the field of micro-enterprise. A strong model is now emerging that Street Kids International is able to share with other agencies. In the 1997 evaluation of the project, participants and their parents or guardians were interviewed and cited the following conclusions.

Personal changes

- Many participants have changed their lifestyle. They now have something to focus on, their self-esteem has improved, they are more responsible and they are perceived by their family and community to be contributing members.
- Parents are particularly impressed that their children are now busy and kept off the street.
- Females say they no longer rely on men because they can take care of themselves. Several mention that they no longer need to engage in casual sex work to earn some money for themselves.
- Males and females indicate that they are taking fewer risks in their sexual behaviour.
- Several young mothers are now able to provide their babies with better care.
- It is evident that most participants are expected to contribute to household income. Many cited contributing breakfast tea, buns and relish. Some ensure that their families eat fish (*kapenta*) more often.
- Participants go hungry less often as a result of the income from their business.
- Participants demonstrated self-confidence and assertiveness in their individual conversations with the interviewers and in group discussions where up to 20 people were present.
- Participants are changing their support structures – as they move away from risky behaviour, they find new friends and supporters.

○ Some participants are saving money on their own in addition to the mandatory ten per cent savings.

Parental/guardian support

○ Parents/guardians are very important to the success and failure of businesses. Some have offered a significant degree of support; others have taken assets/business income and their interference is directly attributable to most of the failed businesses.
○ There appears to be more support for participants coming from parents than guardians.

Impact on family

○ Participants are now contributing to family income.
○ Some participants are lending their money to family members.

CASE HISTORY

Profile of three participants of the Youth Skills Enterprise Initiative; Doreen Kashitu, Fan Kaoma, Frieda Soko

Doreen, Fan and Frieda live in Mutendere, one of the crowded districts of Lusaka. Like many other young people in this area, they were unable to continue their schooling past Grade 7. Half of Zambia's population is under 18 years old and the government is not able to build enough schools to meet the demand.

The three girls are between 16 and 18 years old. They used to spend most of their days doing household chores and hanging around. Fannie also looks after her two-year-old baby.

They heard about the YSEI programme through one of the YWCA's peer educators and they became the first participants in the programme. Being involved in YSEI meant attending six sessions of basic business-management training, getting to know one another, drawing up a constitution for their peer-lending group, and having discussions about issues such as sexual health. They also went on a picnic with a YWCA youth group.

Doreen, Fan and Frieda started a collective business with the $30 loan they each received from the programme. They pooled their money and bought a 50 kg sack of rice which they sold in small bags from tables on the road in front of their homes. Within a month they had expanded their business to include selling peanuts and flour. Each day these young business women take 50 cents from their earnings – the rest of the money goes towards repaying their loan, the interest on the loan, a reinvestment fund for their business, and their personal savings fund.

Doreen is candid about the programme being important for those who don't attend school 'in order for them not to become beggars and prostitutes'. She feels confident that she can now get into other businesses since YSEI helped her to do comparative pricing, to know what may be viable, and to understand the needs of customers. Fan is also excited about what she has learnt in the programme. 'We've now had business experience and I'm confident to expand. We learnt things like cash management and the way of keeping money so we save for reinvestment. Being in business has now become part of our lives.'

Saving money is one of the highlights for Frieda. She proudly states that she now has 6,975 kwacha ($7.00) in savings. She also talks about how the three of them did not previously know each other but through the programme have become close friends. When Fan's baby was sick and in the hospital, Frieda, Doreen and Mwaka (their YSEI project officer) all came to visit and offer support.

So, what difference has making a little money each day made? Doreen has contributed occasionally at home to buy food for the family's breakfast – something her family has never been able to afford. She has also bought herself some clothes and toiletries. She even sometimes lends a little money to her mother. Both the Project Officer and Doreen's mother are amazed at the change in Doreen's appearance – they say she looks more radiant than before. More importantly for her mother is that Doreen's business has given her something to do. 'Before she was on the street and now she has changed her lifestyle. Somehow she had others buy clothes for her and now she is buying her own . . . now she is not so vulnerable to AIDS.'

Occasional sex work is the reality for many women in Mutendere. With an HIV rate of 30 per cent among Zambia's reproductive-age population, it is a high risk way to make money. However, it is also one of the only ways for unskilled and uneducated girls to earn any money for themselves. These three young women are adamant that if they were not running their business they would be 'up and down in the street [the code for sex work] looking for money'.

Fan shares a five-room house with 20 other people. Her stepfather is the only one who earns a regular income. He works as a driver for one of the government ministries and gives Fan's mother just $20 each month for household expenditures. It was a relief for Fan to start making some money. 'Finally, I feel independent in my parents' home because I am no longer rebuked for failing to provide for my baby. I am now able to pay for basic needs for my baby and I, once in a while, make contributions towards food for the rest of the family.' Not surprisingly, Fan's dream is to be able to afford her own house, or at least her own room.

Post-script In a visit to the project in May/June 1998, Ann Sutherland (SKI) found that Fan had diversified her business activities by selling more food stuffs and *chitenge* cloth (which women use as sarongs). Six

months after starting her business, Fan's income had increased so significantly that she was able to rent her own two-room house and pay for all of her living expenses. Fan married the father of her child (something she had previously refused to do because she did not think he would be able to financially support the family). She now is confident that she is in control of her life and she has become an assertive businesswoman in the process.

Case history written by Ann Sutherland, SKI, Canada

Model programme
Servol Life Centres: Education for life and work; Trinidad and Tobago, West Indies

Adolescents in Trinidad, West Indies, frequently grow up with negative attitudes toward life because of the violent, impoverished environment in which they live. They typically spend several years 'liming' (loitering with no particular purpose, a term usually applied to groups of unemployed youth in Trinidad) after primary school and develop a negative work ethic which makes them unemployable even if they have a skill.

Servol has been involved in community development in Trinidad for more than 25 years and works to empower its community by offering holistic educational programmes that are totally indigenous and that seek to give people power over their own lives.

Its main programmes are as follows.

- The Parent Outreach programme in which para-professionals (trained volunteers) go from village to village educating parents in appropriate parenting skills and in the importance of proper nutrition and sanitation in the development of children.
- Early Childhood Centres staffed by professional teachers who seek to draw parents and the community into the educational process. In 1998 there were 148 centres catering for 4,000 children.
- Junior Life Centres where after-school programmes are designed to help children aged 13–15 who are not performing very well in the formal education system and are at risk of dropping out. These children are offered functional literacy and are prepared for some form of industrial training.
- Servol Life Centres (described below) where youth of both sexes between the ages of 16 and 19 who have been turned off by the formal system can go.

Since 1980, Servol has been giving especial emphasis to those in the 16 to

19 age group because few other programmes in the country were addressing the needs of this population.

Servol Life Centres place special emphasis on the needs of women in Trinidadian society. First, efforts are made to accept an equal number of males and females into the training programme. Second, priority is given to young women who wish to train in trades that are traditionally relegated to the opposite sex. Young women have graduated in a variety of skills normally performed by males. This emphasis on non-traditional employment for young women helps to undermine sex-role stereotypes and debunks the myth that a woman's place is in the home. To reinforce this policy, Servol also tries to hire female instructors to serve as role models in non-traditional trades such as plumbing.

Servol has developed a unique and successful adolescent-training programme which combines vocational and life-skills courses to equip youth to serve their communities and to function in the working world. The programme consists of two parts, and takes approximately 15 months to complete. The first stage is the three-and-a-half month 'Human-development Course', or 'Adolescent Development Programme' (ADP), which includes training in: self-awareness; spirituality, parenting and family life; nutrition, health, and sex education; drug-abuse prevention and recreation. They are also offered the opportunity to develop their literacy skills and to take part in drama, peer-counselling sessions, art and craft, sports, and community services. As part of the community service aspect, all the students, both female and male, must spend time working with the elderly, the disabled, and infants. In addition, the students spend short periods in different vocational training departments to enable them to make an informed decision about the types of skills they want to learn. All students must complete the human-development course in order to proceed to the vocational training.

The human-development course portion of the programme is considered by Servol to be the essential ingredient that leads to the high rates of success in training and graduate employment. Indeed, the firms which employ Servol graduates say that: '. . . they do not see skill training as a requirement for employment in their companies; all they are looking for are people who are punctual, hard-working, honest and able to get on with their fellow employees.' (Pantin, 1989).

Approximately 80 per cent of the students go on to the second stage of the youth training – a year's vocational training course – and those who perform well are offered a place on the Job Training Programme. Students choose from a range of possible trades including: childcare; masonry; auto mechanics; air-conditioning, computer repair, micro-electronics, beauty culture, electrical installation, computer literacy, food preparation, hospitality industry, plumbing, printing, sewing, welding, woodwork and small-appliances repair. Recognizing the volatility of the job market in Trinidad,

each Servol student must be versed in more than one trade. In addition, students learn basic skills of money management, starting their own business, and applying for jobs.

Graduates are issued certificates of performance for all trades (including those thought of as female occupations). For all trades, Servol has negotiated with the government and is able to issue a performance certificate from the National Training Board. Servol insists that all students contribute to the cost of their education to improve their understanding of the worth of the training. These fees, combined with local income-generation activities, enable Servol to self-finance a large portion of the costs of training. Servol also provides an excellent example of a non-governmental organization that has been able to work successfully with the government – often a difficult feat. Since the late 1980s, Servol has worked in partnership with the Trinidad Ministry of Education to expand the programme nationwide. In 1998, forty Servol Life Centres were in operation, training some 3,500 young people at any point in time.

Servol is also an important example of an organization that works with young men and women, and that seems to look at their gender-specific needs and risks. The programme also works with young men to improve gender equity. For example, the programme reports that by requiring young men with the programme to work a certain number of hours each day in day-care, young men grow more confident and proactive in childcare, gaining greater understanding of and satisfaction from their role in parenting.

Model programme
Child Welfare Society of Kenya: Empowering domestic workers

In Kenya, as in most countries, the life of a young woman involved in domestic work (*ayahs* as they are called locally) is tedious. A 1991 study of domestic workers aged 10 to 25 in Nairobi found that the average day started at 5 a.m. and ended at 10 p.m. Monthly wages ranged from about US$7 to US$18. The majority of the girls had migrated to the city from rural areas and sent much of their income home to their families; some did not even know how much they earned since the money was sent directly to their families. Roughly two-thirds of the young women interviewed had completed no more than six years of schooling (Onyango and Orwa, 1991). Their main desire was to go back to school or to receive some kind of training that would help them get a better job.

A 1985 study of girls in domestic work highlights the reasons why so many girls in Kenya are in domestic work: one-third said they had no money for school fees; one-third cited poverty in the home; and about 12 per cent said they had to drop out of school because of pregnancy

(UNICEF-Kenya, 1989). Domestic workers came to the forefront of public attention in the late 1980s in Nairobi with numerous press reports of domestics who had abused or neglected the children of their employers. In one case the reported neglect led to the death of a child. The incidents spurred a public debate about the lack of training for domestic workers. Despite the apparent danger, many Kenyan families acknowledged that they preferred untrained domestics so that they could mould them according to their liking.

Responding to the perceived need for childcare training for domestic workers, the Child Welfare Society of Kenya ('the Society'), a non-governmental organization that provides services for low-income and abandoned children, decided to form a training programme for domestic workers. The chief impetus for this was a concern about a lack of trained personnel to provide day-care for the pre-school children of employer families. The Society combined this interest with a concern for improving the status and working conditions of young women in domestic work. According to Ambrose Otieno, Director of the Domestic Workers Training Programme: '[Most domestics] have no motivation, education or skills necessary for the performance of their job. They are underpaid, if paid at all, and treated no better, if not worse than, household pets.'

The goal of the training programme is thus two-fold:

o to provide young women with training in childcare and thus improve the quality of childcare in Nairobi; and
o to upgrade the status of domestic workers in Nairobi, thereby leading to higher wages and better working conditions.

The target population for the course is low-income, unemployed young women aged 15 to 25, or young women already employed as maids or domestics. As a prerequisite, the young women must have at least standard 7 level (7th Grade) schooling and be able to read and write English and Swahili at a basic level. In practice, however, the programme has accepted young women with much lower educational attainment. Most of the girls and women who have attended the course worked in homes as domestic workers before and during the training. A few were unemployed, and others worked in institutions (such as childcare centres or residential programmes for children.)

In conjunction with the Kenya Institute of Education (the research and development arm of the Ministry of Education) and the Ministry of Culture and Social Services, the Society developed a curriculum for the domestic workers training course which includes child development and childcare, home management and cooking, first aid, nutrition, budgeting, personal hygiene and employer–employee relations. The training centre shares space with the Society's Baby Wing, a centre for infants awaiting

adoption, where the young women receive practical experience in childcare. The young women also have assigned practical experience with families.

The training is offered as a three-month, full-time course, for which the girls have to pay 120Ksh enrolment (about US$4) and 100Ksh per month (less than US$4). At the end of the training the young women take an exam, and if they succeed obtain a diploma, which is recognized by the Kenyan Ministry of Labour. Between 1987 and 1991, 312 girls applied for the training and 171 were enrolled and trained. By the end of the last course, 470 potential employers had applied for trained maids after having heard about the programme in the press – leading to more than two job offers for every graduate. Virtually all those graduates who were employed found their jobs through the training programme.

Upon leaving the training course, a majority of young women said they did not want to be domestic workers for the rest of their lives. Indeed, after participating in the training course, most of the young women choose not to work as live-in maids, instead preferring and securing better pay and shorter hours in childcare institutions where they earn an average of $68 per month. Young women who have participated in the training course, report that their income before the course ranged from US$17 to $41 per month as a live-in maid. The Society has combined the training programme with advocacy on behalf of domestic workers. Thus, the indirect result of the programme has been to raise the status of domestic workers to that of a viable and dignified profession.

Model programme
The SIMMA Vocational Training Institute and the WACAR Foundation (Women's Association for Counselling and Rehabilitation): Empowerment of women for better prospects and sustainable development; The Gambia

The Gambia is one of the smallest countries in West Africa, surrounded by Senegal on all sides except the west where it meets the sea. The country's population is 1.1 million, with a life expectancy at birth (in 1995) of 46 years (World Bank, 1998). Less than 20 per cent of children have access to secondary education (ibid.) and school enrolment for girls is below 50 per cent.

The Gambia belongs to the group of least developed countries in the world and remains one of the poorest countries in Africa. Living standards are relatively low and the majority of the rural population is faced with inadequate education, healthcare, sanitation, nutrition and so on. Girls and women and their children are the most affected by these privations.

Women in The Gambia work very hard. They produce 90 per cent of the food and their role in the overall socio-economic development of the

country so far cannot be over-emphasized. Yet they face obstacles such as limited access to and retention within the educational system, inferior social status, systematic discrimination, and violence and subjugation in the name of socio-cultural values, Islam and tradition.

Children between 12 and 15 have to undergo a series of school examinations to determine whether they will have a place in the (secondary) education system. However, due to the very limited number of places available, only the better prepared are likely to succeed. Those children unable to secure a place in a secondary school will go on a vocational training course (if they can afford it). These under-aged, unskilled and semi-literate children will face very limited employment opportunities.

SIMMA (Satang's Institute for Management and Marketing Auditorium) was founded by Satang Jobarteh in 1991 when she started, at her own home, offering underprivileged girls and women training in typewriting and office skills. As the demand increased, the SIMMA Vocational Training Institute moved to rented accommodation. Alongside the typing school, SIMMA has a restaurant with the objective of raising funds to support the Institute. A reasonable fee per student has been agreed in order to cover the operational costs of the Institute. Between 150 and 200 students aged between 15 and 35 enrol at SIMMA every year for a two-year training, 95 per cent of whom are girls and young women. The students are children of poor families; semi-literate youth who wish to improve their literacy skills; school-age children who are unable to get a place at senior school and rural migrants in search of vocational qualifications. Through SIMMA, most of the graduate students go on a work placement in offices throughout The Gambia, which often leads to employment.

In January 1995 the Institute expanded from offering typewriting and English language to include secretarial, accounting and computing skills. The Institute has also been recognized by the Department of Education and is now preparing students for internationally recognized qualifications in secretarial, computing and accounting skills (Pitmans and RSA). The Centre has been working in partnership with the Agency for Personnel Services Overseas and Voluntary Services Overseas in skills-sharing and capacity-building. Both agencies provide SIMMA with volunteers for two-year periods.

SIMMA also organizes 'extra mural classes' which are weekly meetings to discuss the personal problems of the girls and young women together with wider issues such as gender disparities in society, early marriage and teenage pregnancy. As a response to the needs expressed in these classes the WACAR Foundation (Women's Association for Counselling and Rehabilitation) was established in 1996. The foundation aims to create opportunities for the advancement of girls, young women and their children, and to address some of their problems. It attempts to increase gender-awareness, challenge negative misconceptions and values, create opportunities for the

advancement of women, and equip girls and young women with skills for self-employment.

SIMMA's existence has contributed significantly to providing poor families with an additional and affordable vocational training opportunity for their children, and to reducing teenage idleness due to lack of places for further learning. Girls and young women participating in SIMMA have delayed marriage and learned to avoid teenage pregnancy. However, some of the major problems faced by SIMMA are a lack of adequate resources and a lack of jobs for all their graduates. Moreover, many students have to abandon the course after enrolment because they are unable to pay the minimum fee charged by the Institute.

Elements of success: Income generation and vocational training

In reviewing the three case studies highlighted here, a number of conclusions and elements of success stand out.

Exploiting the demands of the market

Vocational training for girls and young women is more likely to succeed if offered as a response to the demands of the job market. For example, one chief element of success in the Domestic Workers Training Programme is the fact that it combined an interest in improving childcare in Nairobi and the situation of pre-school children, with a concern for domestic workers. The Child Welfare Society recognized that in essence employers of domestic workers look after their own interests: they are chiefly concerned with the wellbeing of their children, not that of their maids. By approaching the issue from the point of view of providing better childcare, the training programme responded to a need which employers perceived as important. The Society saw a niche in the market that it was able to use to improve the situation of domestic workers.

Using the media

The media is a powerful means of reaching a large audience and, when possible, should be used to attract girls and young women to programmes and also to raise awareness on relevant issues. The Child Welfare Society of Kenya has made the fullest use of the press to publicize the results of its training programme – relying on its media contacts, calling press conferences, and publishing its own materials on the programme. Nearly all the families who sought graduates of the programmes, and many of the young women referred to the course for training, said they had heard about it from the press.

Instilling a work ethic
Girls and young women at risk often lack habits such as punctuality, a sense of pride in their work, self-presentation skills or personal hygiene that are necessary for acquiring stable employment or being successful in self-employment. Both YSEI and SIMMA focus on instilling the work ethic, and teaching skills and habits conducive to seeking and maintaining employment.

Conflict-resolution skills
As YSEI has found, the development of conflict-resolution skills is a critical part of any vocational training programme that aims to prepare girls and young women to cope better with the difficulties of adapting to the conditions of employment or self-employment.

Providing a sheltered environment
Both vocational training and programmes offering other areas of assistance to girls and young women at risk have found that it is crucial to offer them a place where they can meet and have time to learn new skills and develop a sense of self-confidence.

Promoting non-traditional skills
Many projects recognize the importance to overcoming sex-role stereotypes by hiring women instructors in traditionally male-dominated fields and offering vocational training to young women in the same fields. Servol, in particular, stands out as a programme that has sought to effectively address sex-role stereotypes.

Collaboration with the government
Many programmes recognize that if they can manage to collaborate with the government they will be able to offer a wider variety of services or reach a larger audience. The Domestic Workers Training Programme in Kenya, for example, relied on the government to develop its training curriculum – a field in which the Kenyan Ministry of Education has expertise. Following The Gambian government's recognition of SIMMA's contribution, the employment prospects for their graduates have improved.

Lending money to youth is different from lending money to adults
YSEI experience has revealed that when working with youth, staff need to spend considerable time developing a relationship of trust with each child. The first loans will generally need to be small and the loan repayments may initially have to be collected each day.

3. Formal and Non-formal Education

'States Parties recognize the right of the child to education, and with a view to achieving this right progressively and on the basis of equal opportunity, they shall, in particular . . . make education compulsory and available free to all . . . and take measures to encourage regular attendance at schools and the reduction of drop-out rates'
(Article 28, Convention on the Rights of the Child)

'. . . I was in my last class and was about to take exams . . . when I found out I [was] pregnant and I left school. I left school because it was against the rule. I was vexed when I [found out] I was pregnant because I could have passed and gone to secondary school and [gotten] a good job.'
(Teen mother, aged 16, West Indies)

Introduction

FOR THE REASONS cited in earlier chapters, young women in developing countries are far more likely to drop out of school – or never to enrol in the first place – than boys. Enrolment rates for girls tend to be higher in urban than rural areas, yet in low-income families, young women are still especially vulnerable to being forced to drop out of school at both primary and secondary stage.

UNICEF, the World Bank and other international organizations as part of the 'Education for All' initiative have proposed numerous measures to improve the educational prospects for girls. These include:

o gender-sensitive teaching materials and curricula
o gender-training for teachers
o recruitment of more female teachers
o measures to insure the privacy of girls, including separate schools
o flexible hours and schedules which work around the girls' work day
o scholarships and incentives for families to keep girls in schools and childcare programmes to relieve them from care-taking for younger siblings instead of attending school
(World Bank, 1991; NGOs Working Groups on Girls, 1998).

For at-risk urban girls and young women, even more specialized measures may be required, such as:

o intensive remedial education for young women who are re-entering the education system after being outside it for several years

- non-formal education that meets immediate practical needs for daily survival
- day-care services for adolescent mothers who want to return to school after the birth of their child
- night classes or weekend classes for working girls, or girls in domestic work who cannot take time off
- special emphasis on education in order to empower girls by developing their confidence and skills
- curricula which encourage the active participation of students.

While the obstacles often seem enormous, programmes that have offered basic education and literacy for at-risk adolescent women have been met with tremendous demand and able audiences. In Senegal, Enda, a non-governmental organization, for example, found that girls would come for literacy classes after working 13-hour days for the chance to learn to read as described in the case study below. In Guatemala, another non-governmental organization, PERA, found that working girls would attend classes on Sunday after working six-day weeks for the chance to complete their primary education. In Jamaica, the Women's Centre found that even girls who had left the school system due to a pregnancy could get back on track if the right combination of health, education and day-care services were made available.

> 'Study after study has shown that the education of girls is one of the best investments available to developing countries. It can increase incomes. It can help free women from subjection. It can lead to better child health and nutrition. It can mean later marriages and lower birth rates.'
>
> (UNICEF, 1996)

In promoting girls' and young women's education, we must not forget that structural socio-economic inequality deprives *both* girls and boys of adequate schooling (Knodel and Jones, 1996).

Case study
Adolescent Mothers Programme of the Women's Centre of Jamaica Foundation: A second chance for education

Jamaica, like many other countries, has extremely high rates of early childbearing. About 10 per cent of women aged between 15 and 19 give birth each year, comprising more than one-fifth of all births (Alan Guttmacher Institute, 1998). Conditions of poverty in Jamaica encourage early sexual activity. In poor households, many of them headed by women, the mother often works long hours. She is too exhausted physically and emotionally to educate her growing children about their sexuality and family planning. In

addition, young men and women seek to have children early to prove their fertility. Pregnancy to a schoolgirl means forced expulsion or drop-out so the mother can care for the child and/or work at the same time.

'Visiting relationships' (in which youth continue to live with their respective families but have a sexual union) are common in urban Jamaica. A 1984 study estimated that for the Caribbean region as a whole, the 'visiting union' accounts for over 60 per cent of unions among women under age 30 (Jagdeo, 1984). In such situations, a young woman who becomes pregnant usually faces the situation without a stable partner. In 1989 the Statistical Institute of Jamaica (STATIN) found that 23 per cent of all births occurred to teen mothers. Young women often go through a series of 'visiting partners' and it is not unusual to find young female-headed households with a combination of children from various fathers. Women typically remain on their own and raise their children, and often their daughters' children.

In most cases, a pregnant schoolgirl stays at home with her family. In other cases, shame or poverty fosters resentment at having more mouths to feed and the young woman may be forced to leave home. More commonly, however, the cycle of early childbearing is simply a repetition of what happened in earlier generations and the saga of the female-headed family continues.

Prior to the inception of the Women's Centre of Jamaica Foundation programme for adolescent mothers in 1978, a pregnant young woman in Jamaica was not permitted to remain in school after her pregnancy became known, or to return after giving birth. She was forced to drop out and join the ranks of unemployed, unskilled mothers. The chief goals of the Women's Centre are: (1) to assist girls who become pregnant while enrolled in school to continue their education; and (2) to delay subsequent pregnancies.

Girls who get pregnant while in school are referred to the nearest Women's Centre by counsellors, teachers, prenatal clinics, government and private agencies and word of mouth. Services offered include academic instruction, counselling, outreach to adolescent fathers, and skills training (sewing, home management, cosmetology, chicken, fish and vegetable farming, beekeeping, and doll-making). Other services the Centre offers include a day nursery, parenting skills training, family-planning services, income generation, and recreation.

There are seven 'Women's Centres' spread across Jamaica. Each year these centres reach over 1,500 young women aged 11 to 16. To date (1997), the programme has assisted nearly 23,000 young mothers. The primary focus of the Women's Centre programme is its classroom instruction and educational support. The young women are able to study in a comfortable environment, rather than facing difficulties or embarrassment at school due to their pregnancy.

The Adolescent Mothers Programme attempts to relieve the negative effects of early unwanted pregnancy. Pregnant school-age girls (i.e. 16 years and under) continue their academic education at the Centre and are returned to the normal school system after the birth of their babies. Usually the young women remain in the Women's Centre for two semesters before returning to the formal education system. Academic instruction is augmented by group and individual counselling, with emphasis on achieving a 'better me'. This results in the return to the school system of a self-assured young woman, better prepared for her role in society.

The Kingston branch of the Women's Centre is also a government-designated examination centre. Thus the young women can take the 10th and 11th Grade CXC exams that are required for any further studies beyond high school. The programme's goal is to work with the family and keep the girl at home whenever possible. Where a young woman has had to leave home because of her pregnancy, the Centre's staff meets with the family and work to get her back home. In all but one case they have been able to do so.

Programme evaluations to date show that the system is working well. In a 1988 study conducted with the assistance of the Population Council, there were significant positive differences between control and client groups in terms of return to school after pregnancy (13 per cent of control versus 44 per cent clients), remaining in school longer, higher earning levels, and fewer subsequent pregnancies (Population Council, 1989).

In a tracer study conducted by the Women's Centre staff in 1995, 180 randomly selected graduates of the two oldest centres (Kingston and Mandeville) were surveyed 8 to 12 years after leaving the Centre Programmes, and the Population Council findings were basically reaffirmed. Of the total Jamaican population of girls who had their first pregnancy at age 15 in 1979, 26 per cent of them had a second pregnancy in the next year. The graduates of the two centres, on the other hand, averaged 5.5 years (for Kingston Centre) and 3.3 years (for Mandeville) before their second child was born. The average number of children these graduates had was much lower than the general population, and they had a higher level of educational achievement (as, it appeared, did their children), as well as higher earnings.

Another recent study conducted surveys with a client group of 232 and a control group of 145, and held interviews with selected teenage mothers, their own mothers, and their 'baby fathers' (Chevannes, 1996). The three main benefits documented in this report were as follows:

○ Women's Centre clients had a back to school rate of 47 per cent compared with 18 per cent of the controls
○ Women's Centre clients had a contraceptive use rate of 85 per cent against 70 per cent of control group

- The repeat pregnancy rate was 7 per cent for the Women's Centre clients versus 17 per cent for the control group: 14 per cent of the clients were pregnant again by the age of 19, in comparison with 30.8 per cent of the control group.

The Women's Centre has also succeeded in maintaining a mix of funding sources. Currently, 70 per cent of the programme's budget comes from the Jamaican government. The programme receives other funding from international donors and a portion from its own income-generation projects. In Kingston, for example, a group of ex-students makes dolls for export. In rural centres, young women may work in chicken and fish farming, beekeeping and vegetable farming, among others. These projects provide funds for the Centre and food to supplement their diets, while teaching participants an additional skill. This mix of funds covers the estimated JD$2,500 (US$70) as of 1997, that the programme spends on each young woman and her baby.

A university economist, Ashu Handa (see Appendix to Chevannes study, 1996), took the findings of this most recent study and provided a cost–benefit analysis of the Back-to-School programme in terms of 'savings' to the country from lowered fertility rates, improved health, higher educational achievements, and higher earnings. The cost–benefit ratio was 6.40 in 1992 and 6.70 in 1993 for every dollar spent on the Women's Centres Back-to-School programme.

Another of the programme's successes has been working with policy-makers and the general public to change negative attitudes towards pregnant schoolgirls. Rather than a concerted lobbying or advocacy effort, the Centre used a soft-sell approach to encourage schools to accept adolescent mothers after their pregnancies. Thus, instead of pressing the Ministry of Education to make it compulsory, the programme used personal contacts with principals, teachers, counsellors and Ministry officials to persuade them that the Centre's approach worked and was important to the school system. The programme also counselled young mothers assisted through the programme to become 'ambassadors' of the programme within their schools.

Initially, the programme sent girls who were returning to school to different schools from those from which they dropped out. Now, some of the same schools will accept the girls back – an impressive testament to the acceptance of the programme.

CASE HISTORY

Ellorine, from teen mother to nurse; Jamaica

Ellorine, who came from a female-headed household, was 16 years old when she got pregnant. She was a brilliant student at the time but was forced to drop out of Grade 9 in high school.

'My baby father wasn't concerned. I was really disheartened. He was very displeased with me and wanted me to have an abortion. [He] showed very little initiative when asked for support for my baby and appeared totally reluctant.' Ellorine also notes that her family and friends were disappointed: 'I was a good student and showed a lot of potential.'

Like many adolescent mothers, Ellorine suffered from health problems associated with her pregnancy: post-partum hypertension and anaemia; she was also underweight.

Ellorine entered the Women's Centre Programme for Adolescent Mothers in Kingston in 1980 and with academic support returned to high school the following year and performed with excellence. During the crucial years after her return to school, the Women's Centre covered her school expenses, since her family could not cope with the added costs of the baby.

After leaving high school, Ellorine became a student nurse before going on to university fo a degree in sociology. She credits the Women's Centre with much of her success: '[the programme] was my wall from which I could launch my educational attack on life. Without this backing I could never have succeeded.'

Source: Women's Centre of Jamaica

Model programme
Enda: Literacy for domestic workers; Dakar, Senegal

Rural-based families in much of sub-Saharan Africa often migrate for work or income-generation possibilities when crops fail, in times of drought or to supplement family income. In Senegal, this migration often consists of young and adult women. In Dakar, while no exact data are available, hundreds if not thousands of young women from rural areas come each year in search of seasonal work. The more fortunate are able to find work as domestics; the less fortunate end up in prostitution.

Since 1985, Enda, a French-based international non-governmental organization, has been working with a group of young women involved in domestic work by providing a combination of literacy, health education and income generation when the girls are in the city. The young women usually migrate to the city for six months of the year to earn money for their low-income rural families and to save a small amount of money for their trousseaus. The girls typically repeat the cycle until they are considered too old for domestic work.

Once in the city, the girls live together – up to 20 in a room. They usually work between 10 and 14 hours per day, earning between 8,000CFA and 13,000CFA per month (between US$32 and $52) if they work for a Senegalese family. The common problems they face include sexual harass-

ment from their male employers, unwanted pregnancies, and a lack of health services.

In addition, many of the girls aspire to work with foreign families – which are numerous in Dakar – where they generally receive better treatment and higher pay (up to about US$120 per month). However, the girls realize that to work in a foreign family's home, they need to be able to speak French. Since most of the young women dropped out of school at relatively young ages, most are illiterate and speak only their native tribal language. Enda took advantage of this desire to learn French, as it would also permit the women to work in other professions or in commerce.

Beginning in 1985, Enda began providing literacy classes to these young women involved in domestic work. Classes are provided at night – which is when the girls have time – for two or three nights a week. The project also includes health education and maternal and child health, mainly for the mothers of the young women in domestic work. Many of the mothers of the young women also migrate to the city and work in pounding millet, an income-generation project which Enda also supports. Many of the women involved in pounding millet were themselves domestic workers when younger.

Up to 1992, Enda had provided literacy training to approximately 300 domestic workers. Enda also works with the young women when they return to their villages – and, indeed, encourages them to return to their villages. Those who are interested in alternative income-generation projects are offered this opportunity. Currently, about 60 young women who have returned to villages are involved in painting, batik-making and sheep-raising with assistance from Enda.

Enda also works with the young women to present a theatre programme to tell girls in the village about life in the city and the difficulties of domestic work. This both prepares them for the challenges they will face if they decide to migrate and serves to persuade them that the city is not always the dream that it appears to be.

Enda's combination of services – both to mothers, daughters, and the rural village from which they come – is an excellent example of a basic education programme which has responded to the needs of the entire community.

Model programme
Paaralang Pantao: Children's Laboratory for Drama in Education and The People's School; Manila, The Philippines

Barangay Payatas is a neighbourhood sandwiched between two urban poor communities in Manila. Payatas has a total land area of 1,330 hectares and an estimated population of 10,000. Out of this population, there are a few professionals, but the majority are labourers and rubbish recyclers.

The rubbish dump is unreachable by public transportation. One has to alight from a corner, and walk a good 200 metres to reach it. Another mode of transportation, of course, is by any of the 230 or so dumptrucks coming from other areas of Metropolitan Manila. These trucks can provide free transportation to the willing and desperate passenger who may find it difficult to come home after seven in the evening.

Non-formal education has become increasingly popular throughout the world since the pioneering work of Paulo Freire and other street educators. For street and working children in particular, a textbook, classroom-oriented curriculum is often not viable. The People's School is one of the successful projects that has developed innovative and specialized techniques of non-formal education for children in difficult circumstances.

The People's School is one of the outcomes of the work of the Children's Lab, which began in 1982 as the Textbook Theatre project catering to school children. Through the use of drama and play, the theatre sought to make learning come alive on stage. In 1986, the theatre moved its stage to the parks and streets of Manila and began to serve street and working children. The 'textbook' was adapted to suit the reality of these children – the daily reality of life on the streets.

The People's School is owned and operated by the community, and the Laboratory only plays a supporting role, especially addressing macro issues. The children and youth decide what are the main issues they want to address at school and currently (1998) their priority agenda is:

o gender inequalities
o urban and rural child labour, including street children
o sexual abuse
o youth health and development, including HIV/AIDS
o illiteracy, including early childhood care and development
o food security, including nutrition, water and sanitation
o children's rights and responsibilities.

Drama in Education and Children's Theatre (DIECT), the educational methodology used by People's School, espouses the use of play and games to ensure that children participate in and are stimulated by the educational process. The children become the protagonists of the education rather than passive recipients. Children's Theatre is thus theatre *with* and *by* children as opposed to theatre *for* children. The full participation of the children means that they are seen as human beings capable of deciding who they are, what they want, what they can do and what they will be.

The methodology adopted at the school has also proven useful as a research technique. It has been successfully used, for example, in conducting research on child sexual abuse. In contrast to the usual direct-interview method which often has limited results, DIECT allows the children to take on roles and act out their experiences.

The programme now includes research in the areas of alternative education, direct service and advocacy. A core group of children from different backgrounds take part in the research projects as active participants and advisers. The advocacy programme involves a street-theatre troupe composed of children and youth who visit the community, entertaining and teaching about the rights of children.

While efforts to improve the learning environment (by providing ample space and materials necessary for quality education) continue, the school is aware that sophisticated facilities can actually overwhelm the children.

Within its overall goal of child empowerment, the People's School has given special attention to the issue of gender. The project has targeted boys as well as girls, with the realization that it is males who typically discriminate. The issue of gender is dealt with in a co-educational atmosphere so as not to enforce existing divisions between males and females. The basic goal is to encourage boys as well as girls to grow up to give equal opportunities to males and females.

In addition, the DIECT educational materials and activities are being adapted to include special gender-sensitizing components. In conjunction with Women Create, a special task-force on gender at the University of the Philippines, Children's Lab and the People's School are developing a 'Primer on Women's Issues and Gender Sensitivity'. The artwork and text focus on the unequal division of household labour and childcare; the lack of female role-models in the community; sexual harassment in the workplace; and the level of child mortality due to high rates of child-bearing under conditions of poverty. The concluding messages illustrate how men can assist with family responsibilities, how women can successfully take on 'male' jobs, and the importance of education for women.

While the results of the project are hard to measure, the idea of a gender-sensitive curriculum is planting the seeds for a fundamental change in the way boys, men and society in general treat young women.

Children's Lab has developed the following materials (used in the People's School and at the local and national levels) – written in Filipino:

o Children's Rights Convention, based on early childhood care and development curriculum (teaching children's rights, their principles and provisions in the day-care centres for young children).
o The child-to-child approach in youth health and development, including sexuality and gender and STD/HIV/AIDS and reproductive health
o Play productions on children and youth health and development.

Some of the lessons learned by the Children's Lab and the People's School are as follows.

o The programme's flexibility encourages the children to participate willingly in various activities.

- Street-based strategies do not disrupt the continuity of existing support networks, whether family, peer or community.
- Street-based strategies serve to inform the children and their families about existing programmes and services of government and NGOs.
- Administrators, street children and their families, should all be involved in planning, implementation, monitoring and evaluation of programmes for street children.
- Creativity is needed in designing programme approaches and activities.
- Programmes can benefit from documentation of various programme approaches/strategies, particularly with mechanisms for feedback to programme implementers.
- Working with the community, though taxing and exhausting, is measurable and concrete.

Elements of success: Formal and non-formal education

In reviewing the experiences of the three projects highlighted here, a number of elements of success stand out.

Advocacy on behalf of at-risk young women within the formal school system

One key element of success in the Women's Centre programme is the fact that it worked diligently to persuade the Jamaican government to change its *de facto* policy regarding the expulsion of pregnant schoolgirls. The programme was also able to persuade the Ministry of Education to let girls with scholarships retain them even if they became pregnant. Working on an individual school basis, the programme was also able to persuade schools to allow pregnant schoolgirls to return to the same schools. Nonetheless, the programme recognized that even if a policy is changed at the ministry level, changing attitudes requires work on an individual level with teachers and school officials.

Collaboration with the government

The Women's Centre's history of funding and involvement with the Jamaican government were also important components in the success of the programme. The project started with international funding, but secured an agreement with the Jamaican government that after a specified pilot period, the project would be supported by the government. Even in a declining economy, the government kept its word. The project has been able to demonstrate to the government that it is an integral part of the Jamaican education system.

Providing classes when and where girls can make use of them

Enda's work in literacy (as well as projects in Kenya, Guatemala and elsewhere) with domestic workers underlines the need to provide young

women with classes when and where they can take advantage of them. Enda's classes, for example, are provided in a room in the same neighbourhood as the girls live, and during hours when they can attend.

An innovative curriculum makes the learning process more effective and attractive

Children's Lab uses drama, music, and dance to encourage the participation of the children. For a child who must endure a long working day, either in the home or outside, education must be combined with stimulating activities like dance to maintain their interest.

Education should be used as a tool in changing societal attitudes

Empowerment of girls and appropriate re-education of boys regarding sex-role stereotypes will change the situation of young women in this generation.

4. Health and Mental Wellbeing

'. . . States Parties recognize the right of the child to the enjoyment of the highest attainable standard of health and to facilities for the treatment of illness and rehabilitation of health. States Parties shall strive to ensure that no child is deprived of his or her right of access to such health care services.'

(Article 24, Convention on the Rights of the Child)

Introduction

ACCORDING TO THE World Health Organization, health includes not only physical but also mental wellbeing. Programmes working with street girls and young women exploited through prostitution report the following as among the mental-health problems they frequently encounter:

o lack of motivation and depression
o repeated involvement in dependent and abusive relationships
o fatalism and a lack of will to take preventive actions or actions that would improve their situation
o aggressive behaviour and high levels of interpersonal violence
o self-destructive behaviour such as self-mutilation.

Programmes for street girls in Brazil, Guatemala, Bolivia and the US have all reported cutting or scarring with knives or razor blades as means through which girls act out this self-destructive behaviour and reflect the low value they attach to their bodies.

Again, many of these mental problems are also common to young men, but young women seem to face greater risks. In Kenya, Aptekar (1997) observed that: 'Because girls have been trained to stay at home and learn from their mothers how to become women, the girls on the streets represent a broken path of development. They are more likely to be on the streets because they have fled from homes which have not protected them.' Boys are more likely to hurt others or manifest calloused attitudes towards them than to manifest pain through the self-destructive behaviour girls use.

Programmes in Kenya and Bolivia report that street girls often form common-law families with street boys in an attempt to replace their home-life. Young women exploited through prostitution may form primary relationships with a pimp. In Brazil and Kenya, some agencies report that girls use sex – in some cases even compulsively – to attempt to fill their need for affection. Likewise, young women working as live-in domestic workers are prone to damaging relationships due to their isolation. In

all of these situations, young women are seeking the affection and love they might have once received in their family.

All these behavioural factors have a direct impact on a young woman's health status. For example, a young woman with low self-esteem or a strong sense of fatalism is unlikely to take preventive measures such as using family planning, seeking prenatal care, or asking a partner to use a condom. However, even when they *are* motivated to use it, most young women in difficult circumstances have little access to public or private healthcare. In interviews with 98 street girls in Bolivia, for example, 65 per cent had never received medical care (UNICEF, Save the Children-Canada et al., 1991). Street girls in Kenya and Brazil report that they are often turned away from public healthcare unless accompanied by staff from a social service agency; some even report being turned away by medical staff who called them 'dirty'.

All the programmes described below consider psychosocial and mental-health factors in their health programmes. In addition, the most effective health programmes for young women combine curative services with health education – both of which are taken to children and youth, rather than making the youth come to the services.

Case study
Casa de Passagem: Health outreach by and for girls; Recife, Brazil

Casa de Passagem (Passage House) was founded in 1988. Its chief goal is to improve the daily welfare of street girls and other low-income young women through health services, income generation and shelter, while at the same time seeking to empower them to change society around them.

Casa de Passagem includes a deliberate focus on the psychosocial and mental-health factors affecting young women in difficult circumstances and uses a feminist paradigm to help street girls recover a sense of self.

Casa makes special efforts to reach the girls on their own terms in ways that are relevant to the girl. This approach has proven successful, especially in educational and health services. For example, in teaching the girls about AIDS, the programme used an example from the streets. First, the girls were shown dirty water under a microscope to help them understand the concept of 'bacteria' and 'virus'. They then discussed with the girls that if they can escape from police, who often harass and abuse them, they can surely escape a 'microscopic' threat like AIDS.

The Passage House offers the following four categories of service.

o *Passage House I*, a drop-in centre where street girls aged 7 to 17 receive counselling and psychological support, basic education, food and shelter, assistance in seeking medical attention, and a space to talk and reflect. One of the chief strategies of the drop-in centre is group

discussion, during which the rules and activities of the House are discussed. At the same time, each young woman has an opportunity to discuss in a non-threatening group environment her situation, history and needs. The girls are invited to start a process that helps them leave the streets and prostitution when they are ready to do so.

o *Passage House II*, the second stage of the project, offers those young women who so desire and are ready, a chance to seek vocational training, income generation, recreation and participation in the community-outreach prevention project.

o *Community Houses*, where girls who cannot be reunited with their parents can live on their own with their young children and receive assistance in acquiring employment.

o *Community Health Outreach*, which is the preventative side of Casa's work. Through a variety of projects, the most important of which is the Health Agents Programme (described below), Casa provides health education at the community level with girls who are at risk of ending up on the streets. Through these projects, the families of the girls also receive assistance.

The Health Agents Programme (AMI – Agentes Multiplicador de Informacoes)

The AMI is a preventative programme, consisting of training girls in a variety of issues concerning young women, so that they can then go on to share the information with their peers in their neighbourhoods. The work in carried out in 11 of Recife's 500 slums and aims to reach girls at risk of becoming 'street girls'.

The girls, who are leaders in their communities and are interested in becoming a 'multiplier of information', go through an eight-month course at the Casa de Passagem. The course is organized in modules such as citizen's rights, health issues (including family planning, body care, sexual abuse, sex education, STD prevention), women's rights, gender, and self-esteem. Approximately 30 girls from the communities and five former street girls are now participating as paid health outreach workers or health agents to their peers. The chief activities include individual and group peer-counselling, condom distribution, preventative healthcare presentations and health theatre.

The programme is based on two important premises.

o The most effective point of intervention to prevent a cycle of early, unwanted pregnancy and sexual abuse is in the communities, aiming both at the girls and at their families.

o The most effective agents or persons to reach adolescent women are other adolescent women, including those who may have faced the consequences of early childbearing and sexual abuse.

The Health Agents Programme was started in 1989 with a technical team of one nurse, one doctor and one educator. Initially, the project envisaged a six-month training period for the girls. However, it quickly became apparent that the young women would need a longer training period. Before they could become counsellors to their peers, the young women had to develop a strong sense of self, and learn to be comfortable with their own sexuality. In addition, some of the girls had to overcome their own past histories of sexual abuse and exploitation. One of the techniques used to help the young women in this process was dance and theatre, through which they began to build confidence and to improve their body image.

The initial idea was that the health agents would work as volunteers. However, it soon became evident that many of the girls had to work to help contribute to their families' income or support their own children. A stipend was therefore added to help the girls financially and enable them to work in the programme. Thus, the health agents took on the additional role of an income-generation and vocational-training project.

Since 1990, the Health Agents Programme has been fully functioning. On a weekly basis, the health agents visit two schools (mainly night schools) reaching between 100 and 200 young women with information on sex education, family planning, AIDS prevention and sexual abuse. They also reach about 300 persons per week, including young women and their families, in low-income communities, through individual counselling, group counselling, and the health theatre. The health agents also distribute about 500 condoms per month.

In addition to their daily work, the health agents have been invited to various local, national and international conferences, and to meet with the Ministry of Health to assist in the development of AIDS prevention materials. In addition, 14 of the health agents served as researchers on Casa de Passagem's census of street girls, and another eight are currently working as survey-researchers on a study of the sexual behaviour of female adolescents. The women receive a full-time minimum wage for their work as interviewers. Because of their understanding of health issues and their special connections to the people being interviewed, the health agents are extremely effective interviewers. In addition, the interview process became a kind of informal counselling session for the girls on the streets and in communities. Finally, the health agents have become politically active, leading marches and civil protests on the local Department of Health to seek better health services for street girls and adolescent women.

The results of the Health Agents Programme have been impressive, not only for the communities served but also for the agents themselves. The young women who currently serve as agents display improved self-esteem and a clear sense of where they are headed. Several are interested in pursuing a career in health. As a result of their increased understanding of the realities of life in Recife's slums, they have also come to understand

their political role and political rights. The project's long-term goal is to persuade the local government to take financial responsibility for the programme by paying at least 20 of the young women to act as full-time government health outreach workers.

CASE HISTORY
Betania, from street girl to mother; Brazil

Betania only met her father once in her life. She says she cannot even remember his face. Her mother had a series of boyfriends, some of whom abused her. As a young girl she went with her mother to the streets to beg and when she was nine years old, she went to work as a live-in domestic for two years. Her employer did not pay her, giving her only room and board. She says she was beaten frequently and later ran away from the house.

After working a short time in another house as a domestic worker, Betania began hanging out with a gang of street girls who invited her to join them. She started stealing with the gang and was later picked up by the police. She spent two years in a government institution before escaping; she was 14 at the time.

Upon returning to the streets, Betania started sniffing glue. She tried returning home again, but ended up in fights with her mother and her mother's new boyfriend. Her mother later injured her with a bottle in an argument and Betania needed medical treatment. After treatment for the injuries, she returned to the streets, where she and her new boyfriend began robbing. At the age of 17 she got pregnant and her boyfriend was arrested for robbery and convicted.

During her pregnancy, Betania continued to use drugs until she met outreach workers with Casa de Passagem. They took her for prenatal care and encouraged her not to take drugs during her pregnancy. She was also offered an opportunity to live in a community house with other young women and to participate in a vocational training in industrial cooking.

Betania later gave birth to a healthy daughter and continues to live in one of the community houses of Casa de Passagem and is improving her skills in cooking. At weekends she visits her boyfriend in prison, and occasionally visits her mother, although she says their relationship has not improved much.

Says Betania: 'I'm happier today because I'm responsible and respected. I have a place to live (the community houses) and I share the house with the other girls . . . I'm legally employed. I like to cook. I'm not a professional yet but I'm trying to be.'

'I have a beautiful daughter, Fabiana, one year and eight months old, and I'm doing my best to bring her up and prevent her from being what I once was: a street girl. Now I'm not afraid of walking on the streets. When I was a street girl, the police used to threaten me because I

> robbed, sniffed glue and fought. Now . . . I respect others and I can go wherever I want. I hope all the street girls can one day be what I am today.'
>
> Case study from 'Betania's Life Story',
> Casa de Passagem, November 1991

Model programme
Kabalikat, Philippines: Health education for street children and bar workers; Manila, the Philippines

The Kabalikat programme, an NGO working in health promotion in Manila, is designed to reach homeless youth and street children, as well as sex workers, engaged in high-risk behaviour. The goal of Kabalikat's AIDS-prevention project is to establish contact with these groups and to develop appropriate education strategies to encourage safer sex practices. As discussed in Chapter 1, commercial sexual exploitation is a serious problem in the Philippines affecting some 500,000 people involved in prostitution, of whom approximately 20,000 are street children (Bagasao and Fellizar, 1992). The majority of sex workers are female.

Kabalikat's pilot work began in 1988 with sex workers in Metro Manila. One of the first undertakings was a study which revealed that 20 per cent of the supposedly adult sex workers were below the age of 17 (Bagasao and Fellizar, 1992). Few NGOs have been able to gain access to the bars, brothels and massage parlours of Metro Manila where these young women usually work. Owners are loath to allow in any group which will reduce their power over the sex worker. To gain access, Kabalikat has had to adopt a non-judgmental stance toward the situation of the women. This does not mean condoning prostitution; rather it means that Kabalikat has decided that these women deserve access to healthcare.

Kabalikat operates through teams of street outreach workers who have gained the confidence of the majority of the brothel owners. They are allowed entry to the bars and parlours, where they distribute information and leave matchboxes with the address of the project.

A recent undertaking has been the training and education of the brothel owners and *mamasans* or madams, who often have the final say over the rights of the women and their access to healthcare, contraception and condoms, and education. Kabalikat offers courses in health education in which they try to 'sell' the idea of safe sex to the bar owners and *mamasans*. The hope is that a *mamasan* with this education will not make her girls have sexual relations with men who will not wear condoms. In most brothels, the women are not provided with condoms and cannot refuse to have sex with a man who will not use a condom. The *mamasans* who graduate from the course are given a special certificate which helps to instil pride and legiti-

macy. In May, 1991, Kabalikat began the second phase of its project by opening a drop-in centre in the heart of the tourist belt where the sex trade is strongest. The shelter is open from 10 a.m. until 2 a.m., to offer a safe haven during working hours.

When Kabalikat began this second phase, it also decided to include street children and homeless youth in its target group. At the time, few other groups were serving the health needs of street children despite their acute need for healthcare. These children have less access to services than the bar workers do, and earn far less money for sex. Including children was a dangerous step as Kabalikat did not want to be seen to condone child prostitution. The stance of Kabalikat is that these abuses will not end without major, long-term changes in the structure of society and the economy. In the meantime, Kabalikat believes action must be taken to reduce the risk to the health and lives of street children trapped in poverty and entering the sex trade.

Kabalikat reaches the children and youth through street educators who gradually gain their confidence through discussion, education, and support offered on the street where the children work. The educators tell the youth about the drop-in centre and leave leaflets explaining the services offered and the location of the centre. Based on their confidence in the street educators, the street children are sure that the Kabalikat staff will not force them to reform or turn them over to the police. The youth learn that they can come to the centre on their own terms to receive counselling, education, food, healthcare, and short-term shelter when ill.

The goal of the project is to provide health education for the street children to enable them to adopt safer lifestyles. However, Kabalikat staff have discovered the unfortunate fact that street children do not take risk seriously until they see and face the direct consequences of the risk. The youth know that they have few opportunities to earn income, and cannot take long-term risks as seriously as the short-term reality of hunger and deprivation. Thus, Kabalikat has learned that the most effective time to reach street children with health education is when they are ill.

Kabalikat takes advantage of these 'windows of vulnerability' and enters into 'health contracts' with the children and youth who require care. For example, a youth who contracts gonorrhoea must agree to stay in the centre through two weeks of treatment to cure the illness. The contract helps them to gain the necessary time to cure the physical problems as well as to provide health education with the goal of preventing future illnesses. In March 1992, the first successful group of children made it through a complete treatment.

A salient indicator of the impact of the programme is the fact that the street children are beginning to recognise STDs in their clients. Not only do they then refuse sexual contact, but they also bring the clients to the centre for treatment.

Model programme
Undugu Society of Kenya: 'Outward Bound' for street girls; Nairobi, Kenya

The Undugu Society was founded in 1972 by the Catholic priest Father Grol in Nairobi, with the primary objective of reintegrating street children into the mainstream education system. Undugu has a long history of successfully assisting street boys – or 'parking boys' as they are called in Kenya – but until the beginning of the 80s had much less success in helping girls leave the streets. According to the Undugu Society, the number of street girls is typically underestimated because they are not counted at night when they are most visible and likely to be working. Undugu calculates that there may be as many as 3,000 girls living and working on the streets in Nairobi, where a large number of them are involved in prostitution.

Undugu staff report that a combination of the income earned from prostitution and the network of common-law 'husbands', boyfriends and owners of lodges who profit from the prostitution make it difficult for street girls to accept the offers for education, alternative employment or shelter that Undugu street educators had previously made to them. In most cases, the girls accepted offers from Undugu when they had cases of STDs – in which situations, the girls asked Undugu to provide them with treatment.

In early 1992, Undugu decided to try something different. In collaboration with Childhope, it held a three-day retreat for street boys and girls and carried out focus group discussions related to AIDS prevention and health. The event was held away from the street. In some cases Undugu even had to get permission from the 'husbands' of the girls so that they could participate in the three-day event. The girls were off drugs for the retreat so that they were able to think, reflect and approach the work seriously.

During the course of the discussions, which gave Undugu staff their first opportunity to work in an intense way with them, the girls said they wanted to leave the street and leave prostitution but added that the influence of friends and 'husbands' was strong. They also explained that income from prostitution provided them with a somewhat stable living.

The retreat was a major success in persuading girls to leave the street. Indeed, all 20 of the girls who participated in the event asked Undugu to help them leave the streets; only one of the girls later returned to the streets. Undugu's conclusion from the event is that girls need a time and space off the streets to reflect and decide for themselves about their future. Acting on this conclusion, immediately after the focus group discussions Undugu organized a week-long 'outward bound' retreat for a number of the young women. The girls went to one of Kenya's national parks and spent the week in a combination of personal reflection, group discussion, and physical exercise. The event was so successful that an additional ten street girls who did not participate in the outing asked Undugu to help them get off of the

streets; they had heard about the retreat by word of mouth on the street. In addition, a number of the girls who participated in the outward bound course said they would like to serve as educators for their peers.

The experience learnt from these courses helped staff to understand in greater detail the different ways in which street life affects the girls compared with boys. Undugu's conclusion is that while street boys are ready to accept whatever they perceive as the best 'offer', street girls develop attachments to common-law husbands and friends, however destructive these relationships may be. It is these relationships which partly keep them tied to the street, often in harmful and abusive circumstances.

In the space of five years, since it started, the Undugo street girl programme has proved to be very successful. This culminated in the recent establishment of the Undugo Girls Centre, called Kitengela, which is situated some 40 kilometres south of Nairobi. This represents the first phase of the Society's plan for rehabilitation of street girls. The 72-bed capacity centre is currently hosting some 68 girls who attend formal schools. Some of the first groups of girls to join the programme have already been reintegrated into their families.

Elements of success: health and mental wellbeing

In reviewing the successes of these three programmes working in health and mental wellbeing for at-risk adolescent women, a number of lessons stand out.

Reaching girls on their own terms
One of the strengths of Casa de Passagem is that it uses the language of the street and the reality of the street for its work with street girls.

Approaching girls in a non-judgmental way
All three programmes highlighted in this section have realised that prostitution is an unfortunate fact of life for many young women – at least in the short-term. Rather than condemning the young women for being involved in prostitution, they try to teach the girls to respect their bodies again, and to give them control over their bodies and their sexuality.

Involving girls in the education of their peers
One of the strengths of Casa de Passagem is that it relies on girls themselves as transmitters of information to other girls in high-risk situations, thus improving their self-esteem. In essence, Casa gives the young women a task, or series of tasks, that is challenging – sometimes just beyond their abilities – thereby encouraging them to constantly improve their skills and aspirations for the future.

Using real health risks as an opportunity for promoting health prevention
Both Kabalikat and the Undugu Society have used the existence of real health problems – specifically STDs – as an opportunity to discuss health prevention, particularly AIDS prevention. Both programmes recognise that these girls are not able to concern themselves with the future. AIDS is seen as a vague concept that will affect others. By using the girls' very real experiences with STDs, however, both programmes have been able to promote AIDS prevention.

Providing space for girls to reflect
All the programmes have learned the difficulty of reaching out to girls while they are in a street environment. Girls need a private space – away from the streets and the negative influence of peers and boyfriends – in order to recover a healthy sense of themselves as women.

Helping the girls and young women to recover and reappropriate their own personal history
Both Casa de Passagem and the Heart-to-Heart project (which is looked at in Chapter 6) have realized how empowering giving voice and opportunity for girls and young women to express their feelings can be. By helping young women analyse and recreate a narrative history of their lives – which is the basis of most therapy – the girls find power in their past struggles and use them to create alternatives for their future.

5. Culture

'... a child belonging to ... a minority [group] or who is indigenous shall not be denied the right, in community with other members of his or her group, to enjoy his or her own culture ... States Parties shall respect and promote the right of the child to participate fully in cultural and artistic life and shall encourage the provision of appropriate and equal opportunities for cultural, artistic, recreational and leisure activity.'
(Articles 30 and 31, Convention on the Rights of the Child)

Introduction

MANY YOUNG WOMEN in at-risk situations have migrated from indigenous areas of the country to work in major cities and, in so doing, have become cut off from their extended families and their heritage. In parts of sub-Saharan Africa and Latin America, for example, certain traditional initiation rites or rites of passage that provide guidance to adult life and a sense of membership in a clan[1] have largely been lost in urban areas.

Indigenous groups often bear the brunt of racism or prejudice and young women, cut off from their families and tribal groups, face this prejudice alone. In the US, Brazil and elsewhere in Latin America, women of African or indigenous descent are further marginalized by coming from a minority group which has traditionally been oppressed.

In addition to the direct benefits to urban young women, the preservation of traditional culture has important spin-offs for economic development. Many development activists have come to appreciate the benefits and knowledge contained within traditional culture. For example, many tribal groups have a symbiotic relationship with their natural environment. Similarly, traditional peoples have preserved intricate forms of art, dance and music that are laden with the richness of culture. A handful of programmes working with at-risk girls and teenage women have included programmatic elements to address the loss or disappearance their culture. Other programmes include a religious element as part of an attempt to provide a connection and sense of meaning.

The programmes highlighted here provide a few examples of such projects. In the US, the Sasha Bruce Teen Mothers Programme, a private organization that serves homeless teen mothers, is building on traditional African and African-American culture through a rites-of-passage

[1] Some traditional practices, such as female genital mutilation, are both dangerous and abusive. These are not the practices we refer to here.

programme. In Senegal, Africa Culture International uses theatre and art as a way to instil a sense of pride in local culture among adolescents and children. FACT in Thailand uses traditional dance in its AIDS-prevention programme. While the focus of the programme is on AIDS prevention, the project also shows how traditional culture can be promoted even in health-education messages. Finally, Kapatiran in Manila is forging linkages between elderly women and young women in difficult circumstances. From the elderly, the girls learn about their heritage and have the chance to adopt a family member.

Unfortunately, too few programmes are currently working to promote traditional culture among at-risk adolescent women and this is an area in need of additional attention.

Case study
Sasha Bruce Teen Mothers Programme: Rites of passage for African-American girls; Washington, DC, USA

> *'The biggest frustration is that we can't tell these girls [teen mothers] what to do. They have to learn it on their own. We have to have faith that if you provide them with examples and guidance, that they will choose the right way. The other thing you can't do is expect miracles. These girls have years of problems and we can't expect to solve them by next Wednesday.'*
> (Staff person at Sasha Bruce Teen Mothers Programme)

The US shares a problem common among developing countries: teenage childbearing. In the US, birth rates among unmarried teenagers and young women are higher than they have ever been. About one million teenagers in the US get pregnant every year; about half of those end in abortion (Alan Guttmacher Institute, 1998). Among black American teen mothers, more than 90 per cent are unmarried at the time of giving birth (Simons et al., 1992). In Washington, DC, teenage childbearing among African-American young women is compounded by the impact of drug abuse, most notably crack cocaine. As families are broken apart by drug use and other problems, a number of teenage mothers end up homeless, without a functioning family or a stable partner.

The Sasha Bruce Teen Mothers Project is a residential programme for homeless teen mothers and their babies which was founded in 1985 to address these problems. The project is funded 100 per cent by the Department of Human Services of the District of Columbia and is licensed for a total of five teen mothers and their babies. The girls can stay for up to two years in the project, with average stays ranging from eight months to one year.

The programme focuses on parenting skills, self-esteem building, educational support, prevention of repeat unwanted pregnancies, vocational

training, individual counselling, family counselling, and 'rites of passage'. The Rites of Passage Programme, which is described at length below, is an Afro-centric, cultural-based programme that seeks to instil traditional African values related to community, sisterhood and self-sufficiency.

Nearly all the teen mothers lack a functioning family, and hence are referred to the programme through the government child-welfare system. For those few young women who have a functioning family or strong family ties, counsellors work with the family to maintain or strengthen family bonds. The fathers of the babies are generally not involved either in the programme or in the young women's lives, although some fathers do help out with the maintenance of the babies. In most cases, the boys want the girls to have the babies but do not have a sense of what it means to be a father. This is largely due to the fact that most of the young men involved never had strong father figures of their own.

Many of the teen mothers suffer low self-esteem, depression, adolescent conduct-disorder, and personality disorders. In addition, some are abusive or neglectful of their children, although there are just as many who treat their children well and are good mothers. The repeated cycle of abuse – mother to daughter to grand-daughter – is a major issue of concern for the programme. Staff report that some of the girls do indeed abuse or neglect their babies in minor ways. Staff say they will tolerate some abuse on the part of the teen mothers so that they can work with the girl. As the programme's director Brenda Lockley says:

> 'We don't kick a girl out for slapping her baby. Instead, we try to work with her. Sometimes the girls themselves realize that they are being abusive. A small minority may even decide that they can't do it (be a mother) any more and opt for adoption. The majority, however, don't want to give up.'

In the past few years, the biggest change in the background of the young women coming into the programme has been as a result of crack cocaine. In previous years, many of the girls they had taken into care had been in the foster care or the child-welfare system for most of their lives, but a growing number of young women now come from families affected by crack abuse. In many cases, the young women's lives were stable up until the age of nine or ten when their mothers started using crack. As Lockley explains it:

> 'The girls had some structure in their lives but then it fell out from under them. The girls themselves are not crack users, but they often have value systems that are based on the materialism of the drug culture. Their boyfriends are often dealers. They often have a dependence on the boys who will buy them things. Their attitude is something like: "My boyfriend will buy me those earrings or those new tennis shoes, so I don't have to worry".'

Boys are seen as having power and the money. As a result, love and affection is represented by the material purchase: 'He must love me if he gives me things. And if he gives me things, then I must have sex with him', Lockley says. In many cases the girls do not have 'girlfriends' per se. Instead, they tend to gravitate toward boys – especially those with money, most of the time earned from drug dealing – as the providers. The young women often end up competing with their female friends for attention and gifts from boys rather than forming any kind of 'sisterhood'.

In response to the complex needs of the teen mothers and their children, Sasha Bruce has created an array of services.

- *Education*: The teen mothers must be enrolled either in school or full-time work. Schooling is geared to their specific needs; those young women who so desire can enrol in a course to study for a high-school equivalency exam. Other young women have attended special schools for youth with learning or personal problems. Whenever possible, however, staff prefer to enrol the girl in mainstream schools. In any case, staff provide tutoring and motivate the girls in their studies.
- *Family planning*: Because repeat pregnancies are a constant issue, sexuality education and family planning are constant themes in both formal and informal counselling. The programme dispenses condoms and contraceptive sponges on the premises; other family-planning services are available through referral.
- *Day care*: Day care is available virtually full time for the children of the teen mothers. If the mothers leave the house for social reasons, they are supposed to pay staff for babysitting. If they leave for 'official' reasons (i.e. school or work), the day care is provided free of charge.
- *Independent living skills*: The programme collaborates with an independent living skills programme run by the local government, which involves teaching the teen mothers budgeting, money management, and other issues related to independent living. This programme involves outside personnel, who are often more effective since the girls often respond with more interest to outsiders than to the same staff they see every day. The teen mothers are also given an allowance which is automatically deposited into a savings account to help them when they leave the programme.
- *Parenting skills*: Staff work both formally and informally with the teen mothers on teaching them to be better parents. One of the staff's main methods is to develop a contract with the young women. The teen mothers agree not to abuse or neglect their babies, spelling out in the contract what they agree to do and what they will avoid doing. Although the teen mothers may violate their contract, this document gives the staff something to negotiate with and helps the young mothers to develop concrete goals.

One of the main points staff try to keep in mind in working with the girls

with their parenting skills is to remember that the teen mothers are in fact teenagers; they cannot be as good mothers as adults. However, the fact that they became mothers while they were still teenagers should not stop them from having the opportunity to grow up.

The Rites of Passage Programme

One relatively new but extremely successful element of the Teen Mothers project is the Rites of Passage Programme, a culturally based, Afro-centric course that attempts to instil cultural values. The goal of the programme is that the teen mothers graduate from a six-month course making a symbolic and actual transition from adolescence to womanhood. The programme also encourages the young women to rely on their female peers for support in an attempt to break the prevailing pattern of negative dependency on men.

The Rites of Passage group consists of 17 young women – the teen mothers plus a group of at-risk young women from a local secondary school. The girls meet once a week for two hours over the course of six months and go on at least one weekend retreat together.

The programme was founded in 1990 when staff participated in a workshop on transcultural communication. As part of the workshop, staff realized the need to 'launch the girls into womanhood' within their own culture – specifically African-American culture. Thus in 1990, Sasha Bruce hired a consultant who helped develop the curriculum and trained the staff. The process started by identifying aspects of womanhood for which they wanted to prepare the girls, including issues related to self-esteem, career planning, community history, cultural history, sexuality and etiquette.

Based on these goals, staff designed a curriculum which includes activities such as:

o a scavenger hunt to find locations important in black history and culture in Washington, DC
o formation of a council of elders based on the fact that in most traditional African communities, elders are revered. The elders talk one-to-one with the girls about what life was like for them growing up in the city, thus broadening their horizons and forming a support network for the girls
o a pledge that is said before every meeting and a traditional African libation to ancestors
o discussion of an African proverb or one of the seven principles of African heritage
o a discussion about a successful African-American woman and invitations to speak to prominent African-American women or women who have overcome adversity. One speaker was a manager of a prominent bank who had overcome a drug-abuse problem

- making traditional African crafts including earrings and tie-dyed *lapas* (traditional African wrappers)
- values debates about issues relevant to the girls. During one session they discussed the following dilemma: 'You don't use drugs and neither does your boyfriend, but he sells drugs'. The debate centred around whether 'It's okay to accept things that he buys me with drug money'
- tracing family trees and family heritage.

At the end of the six-month programme, a graduation ceremony is held for the young women. The graduation is also based on traditional African customs and includes drums, a formal libation to the ancestors, and dancing. The girls are all given African names and, as they make a symbolic transition to womanhood, the elders wrap the girls' heads in the traditional head-dress. Members of the local community are also invited to participate in the ceremony, promoting the idea that these children – as in traditional African-American culture – are part of the community.

In terms of impact of the programme, staff report positive changes in the young women and say the girls learned much from the process about themselves and their heritage. One girl dramatically improved her hygiene and personal appearance as a result of participating in the programme. Another young woman, during the Rites of Passage course, made the decision to go to college, and followed through on her decision. Others, staff say, seem to feel empowered about their heritage. 'In their perception, being black is being at the bottom of the barrel,' says Lockley, 'But it's not; our history is glorious. And when we teach them that, it becomes part of their self-esteem and the results are visible'.

It is interesting to note that a number of programmes working with African-American boys and young men in the US have developed similar Rites of Passage programmes which reinforce the positive aspects of masculinity found in African cultures.

Model programme
FACT: AIDS education through art; Bangkok, Thailand

AIDS is a serious and growing threat in Thailand. Sex workers, particularly the young, are at serious risk of contracting the virus due to the large number of customers they are forced to entertain and extremely low condom use. FACT, a Thai NGO, has reacted to the gravity of the issue by forming the White Line Dance Troupe, an AIDS-education project that uses traditional and popular culture to transmit its message. The NGO was originally formed in 1983 to bring the message of the danger of AIDS to the gay community and the male sex industry. In 1987, FACT began to reach out to female sex workers, concentrating on the lowest-class bars, tea

houses, and on street children, where few other NGOs or governmental agencies were focusing their attention. The decision to expand their efforts was based on the realization that these women were at equally high risk as the young men.

FACT has encountered difficulty in reaching the young women for several reasons: the women have more customers and find it more difficult to use condoms; more women rely on pimps so the permission of the pimps has to be obtained; and the girls were working in many small establishments and were therefore harder to get together than the boys.

FACT currently operates several projects including an AIDS helpline, a counselling programme, and a street outreach project called the 'Cruising Squad'. The White Line Dance Troupe is the arm of the project primarily dedicated to community outreach and education. The Troupe comprises 30 people aged between 11 and 36, the majority of whom are ex-bar workers, both male and female. The youth are being trained as professional dancers, so that the project doubles as an income-generation initiative. The dancers are in turn training additional bar youth as professional dancers. In terms of financial support, the Troupe is able to subsidize its performances in slum communities by performing for fees for large private companies such as Toshiba and Kodak.

In 1990, FACT expanded its AIDS-prevention messages through the dance troupe to the community in general through schools, universities and slum communities. The Troupe also travels to the villages from whence many of the youth in Bangkok's sex industry come. In addition, White Line performs in bars for male and female sex workers and their customers. The message of the show for the sex workers is to empower them to stop deferring to owners and customers who resist condom use. White Line is thus one of the few AIDS-prevention projects able to reach both the sex workers and the customers directly.

The use of prostitutes among Thai men is extensive and culturally accepted. An important part of FACT's work in schools is therefore to change this attitude by persuading the youth not to use prostitutes – thus seeking to change a harmful traditional practice. The presentation to young people aged between 12 and 18 focuses on the idea that Thai men do not have to use prostitutes to prove their masculinity.

FACT realized that the White Line message had to be catchy, popular, and appealing to a variety of different audiences in order to be effective. AIDS is a difficult message to present in Thai society and culture, so the show had to be appealing in its own right to persuade its audience to listen. The 'FACT Show' does just this. It combines modern jazz and rock music with classical Thai dance to transmit educational messages about AIDS prevention.

In one song, for example, several female dancers perform classical Thai dance wearing classical costumes and head-dresses. The words of

well-known popular songs are supplemented with messages about AIDS. The story of the play is that the women are in danger of acquiring AIDS. The AIDS virus is represented by men dressed in black with unattractive masks and banners identifying them as 'AIDS'. The fighter of the AIDS virus is a Thai kick boxer – a popular character among Thai youth and children. The boxer is initially overcome by the viruses which begin to attack the Thai princesses. In the second round, the boxer and the women use large tinfoil packages of condoms to overcome the AIDS viruses and to triumph. The next portion of the act is an open and humorous discussion about AIDS. Condoms are given out, and a condom demonstration contest is held involving people from the audience and using vegetables.

The FACT Show has dynamism and popularity; literally hundreds of slum dwellers of all ages attend the shows. Indeed, the key to the success of White Line is the quality of the show. White Line's work means that the AIDS-prevention message is finally being heard through popular and traditional art – a medium acceptable to both old and young.

Model programme
African Culture International: Theatre of change, theatre of tradition; Dakar, Senegal

Urban youth and children in Dakar, Senegal are bombarded with mass media and other images promoting western culture. In the process, much traditional art and music is being lost or falling out of popularity with the young.

Working in urban slums around Dakar, African Culture International (ACI) is a theatre and arts programme for children and youth that focuses on preserving and strengthening indigenous African culture. The programme also tries to give youth and children meaningful activities in the time they spend outside school. The school day in Senegal only occupies half the day and many youth are left idle (if they are not working) the rest of the day.

To promote African culture, ACI teaches children and youth traditional songs and dance and holds discussions about traditional African values, using drama as the focal point. The drama portion of the programme is run by an energetic ex-street youth, with the assistance of several other young professionals with an interest in art and drama.

During a recent drama session, for example, the leader asked a group of young children to pretend that they were begging on the street. Some pretended to have leprosy, while others pretended to be blind. (In Islamic tradition, begging is considered acceptable for those with certain conditions and is a commonplace occurrence in Dakar.) Two of the leaders then

proceeded to act like a wealthy husband and wife and made fun of the beggars and demeaned them.

After the couple had ridiculed all the beggars, one of the children (who had been assigned the role) began to sing a song about the dignity of beggars and all the other children joined in the song. As a conclusion, the lead actor talked with the children and youth about the importance of respecting street people and about the importance of taking responsibility for one's own actions, thereby avoiding situations in which one would have to beg.

The drama programme exemplifies the kind of community and self-help attitude that ACI promotes. All the persons involved in ACI are volunteers; the concept of the programme was to give something back to their communities. They work in their spare time and give their time free of charge to the project. For its reliance on volunteers and its use of drama and arts in neighbourhoods that have few resources, the project is an excellent example of local initiatives to assist low-income youth that can be started with a minimum of funding and can yield impressive results. In bringing boys and girls to work together, the project enables boys to see girls as equals from an early age.

Model programme
Kapatiran-Kaunlaran Foundation: Linking the elderly and youth; Manila, the Philippines

Kapatiran-Kaunlaran Foundation is a multi-service NGO, reaching out to almost all sectors of the Manila population. Services range from maternal-health programmes to services for senior citizens. Among their programmes is a residential shelter for female drug-abusers aged 9 to 18 called the Therapeutic Community for Women. The Centre focuses on treatment and rehabilitation for the young women, many of whom are former street children and victims of sexual abuse or exploitation.

The centre maintains a special focus on providing a sense of family and belonging for the girls to fill the gaps of abandonment and loss. An important part of this process is bringing the girls into contact with the elderly of their community.

Kapatiran also runs a day centre for the elderly. The original purpose of the programme was to provide the *lolos* (grandfathers) and *lolas* (grandmothers) with a centre where they could come to meet and share their lives, helping them to enjoy their years of freedom. In the Philippines, poverty has meant that, in the past, few people survived to become elderly and those that did were respected members of society. As this changes, more and more elderly people are found in society and the traditional respect Philippine society had for the words of its elders has been lost. They are

often rejected, both by society and their families, and their skills remain unused.

Kapatiran has discovered a way to give purposeful use to the skills of the elderly: allow them to assist the young women in the therapeutic community. The relationship is mutually beneficial; the girls regain a family and learn skills and the elderly have a new purpose in life. The seniors share many activities with the girls, including a small income-generation project. For example, the older women teach the girls to make crafts and jewellery which are then sold. In addition, the seniors and the girls go on out-of-town trips and participate in aerobics classes together.

The success of the programme has convinced Kapatiran of the need to encourage the senior citizens to participate in other aspects of the programme. Many seniors have now received special training as counsellors; they staff a telephone hotline and counsel the young women, offering 'respected' advice. The girls are eager to express their feelings about the programme with the elderly. They recognize that they are learning life-skills and income-generation skills. In addition, they say that the elderly remind them of their grandparents and thus help them to build new family relationships.

Elements of success: Culture

In reviewing these examples of projects promoting culture for at-risk young women, a number of lessons stand out.

Drawing on elders and local resources
All three projects rely on local artists and others to give their time to the development of the programmes; on most occasions, this time is offered free of charge. This involvement of local community artists and leaders also serves to make the projects community-oriented.

Including culture in programmes with other goals
Neither FACT nor Sasha Bruce has the promotion of culture as their main goal. In the case of FACT, the goal is AIDS prevention; in the case of Sasha Bruce, it is providing social services to homeless teen mothers. Both programmes, however, have included promotion of traditional culture at a minimum cost and use popular and traditional culture to attain their end-goals of assisting youth.

Using cultural activities to fill spare time
Many youth – both young men and young women – in urban areas around the world have tremendous amounts of spare time that is often spent idly. African Culture International provides an excellent example of a low-cost

and productive way to fill this spare time – an example that NGOs and governments could follow.

Promoting popular culture through income-generation activities
Both FACT and African Culture International have been able to promote traditional culture and at the same time make money for youth. FACT charges fees in some cases for its performances, while African Culture International has held artisan fairs to sell the work of local artists.

Restoring a sense of family
Young women can develop mutually supportive relationships with the elderly, helping them to get back in touch with their heritage. These relationships are good for both parties because they act as substitute families.

The need to promote elements of indigenous, minority cultures
In order to assist girls and young women from indigenous, minority cultures to connect with their cultural roots and identity, programmes must find ways to value that which is frequently devalued by society. Both Sasha Bruce and ACI have successfully been promoting these minority cultures by using African rituals for African-American girls and rural/tribal aspects of culture for migrants to urban areas. As a result, they are not only helping these girls and young women to make that connection but also to appreciate it and be proud of their own roots.

6. Advocacy and Protecting Girls' and Young Women's Rights

'States Parties shall respect and ensure the rights set forth in the present Convention to each child within their jurisdiction without discrimination of any kind, irrespective of the child's or his or her parent's or legal guardian's race, colour, . . . or sex . . .'
(Article 2, Convention on the Rights of the Child)

Introduction

BROADLY SPEAKING, ALL the needs of urban adolescent women discussed in this publication fall into the category of denying rights or failure to protect young women. Nonetheless, there are a number of notable projects which work specifically to protect and prevent the infringement of young women's rights. There has been growing attention in recent years to women's rights and, within the international development arena, increased efforts at targeting the rights of the girl-child. In addition, both the Convention on the Rights of the Child and the UN Fourth Convention on Women with its agenda for action on behalf of girls and young women – along with local legislation and policies – provide concrete tools to protect young women. However, frequently, pronouncements on the rights of young women and girls remain at the level of good intentions. In addition, there are number of serious obstacles to reaching urban young women at-risk to either inform them of their rights or work to protect these rights, including the facts that:

o young women are frequently unaware of their rights
o young women in domestic work or exploited through prostitution are frequently hidden, and thus reaching them to inform them of their rights is difficult
o in many cases, employers (particularly in the case of brothels and house holds of domestic workers) actively work to see that young women are *not* informed of their rights.

Over the past 15 years important strides have been made in providing legal recourse for adult women who have been victims of rape, sexual abuse or discrimination on the basis of sex. For young women, however, their status as a minor – and their consequent dependence on an adult or an institution to represent them – often creates serious difficulties. In the case of sexual abuse, for example, the perpetrator is often the stepfather, father, a relative

or family friend. In many cases, a young woman is dependent on her mother to protect her from this abuse. Far too often, the mother will deny the abuse. In such cases, owing to her dependent status, the girl has few options. Unless she abandons her home, she is likely to continue to suffer from the abuse. In other situations, legal or child-welfare authorities may not take her charges of abuse seriously.

Unfortunately, this situation is alarmingly widespread. Limited data from the US, Papua New Guinea, Panama, Mexico and Malaysia has found that young women aged 15 and under represent between 33 per cent and 58 per cent of rape and sexual assault victims (Heise, 1992).

In terms of labour rights, urban young women often work in the informal sector, which typically avoids government regulations in general, including those related to labour rights. Even in cases where unions may exist – such as those for domestic workers or garment industry workers – young women are often not included. In the case of girls working alongside family members on the street or in home-based industries or young women sold into prostitution, the family itself may be an accomplice to the infringement of the rights of their daughters. In cases of extreme poverty when the labour rights of the parents are not respected, it is highly unlikely that the rights of working minors will be protected.

In other cases, laws may exist to provide minimal protection for adult women but not for young women. In some Latin American countries, for example, health laws require that public health authorities provide regular medical examinations for sex workers. However, in these same countries, since prostitution with a minor is illegal – and therefore not recognized – young women under 18 who are involved in prostitution do not receive even this basic service.

The projects highlighted in this chapter have sought to confront these obstacles, working at the international, national, local and even individual level to protect young women's rights. The Inter-African Committee on Traditional Practices Affecting the Health of Women and Children (IAC), for example, uses existing human rights conventions and national legislation and policy in an effort to eradicate harmful traditional practices, particularly female genital mutilation, which affects millions of young women and girls both in urban and rural areas. Similarly, the 'End Child Prostitution, Child Pornography and the Trafficking of Children for Sexual Services' (ECPAT) movement uses international networks to protect children exploited through prostitution and to bring charges against abusers. In Thailand, the Kamla project works at the local and national level to raise awareness about practices used to lure girls into prostitution. In the US, the Heart-to-Heart project works directly with adolescent mothers, many of whom were victims of sexual abuse, to prevent the physical and sexual abuse of their children and themselves.

Model programme
The Kamla Project: Preventing sexual exploitation of girls; Thailand

The Foundation for Women (FFW) comprises the Women's Information Centre, the Home for Battered Women and the Kamla Project. The principal goal of the Foundation is to promote the rights of women as promulgated in the UN Declaration on Human Rights. The programme was founded in 1984 with the opening of the Women's Information Centre.

The original goal of the Women's Information Centre was to assist Thai women seeking to go abroad to improve their lives – a risky prospect which often ends in prostitution. Over time, the project came to realize that one of the fundamental impediments to women's development was the lack of understanding of women's issues among policy-makers, planners, and women themselves. In response, the Foundation for Women developed the Women's Education Media which seeks to build up the understanding of and about women in different sectors through newsletters, seminars, research and publications.

In 1986, the Foundation chose to respond to the high rate of domestic violence against women by opening the Home for Battered Women. Aside from offering direct service to victims, the project aims to raise public awareness about violence against women and the socialization of unequal male–female relationships. The Kamla project was initiated in 1987 as part of the Women's Education Media campaign out of concern for the plight of young females forced into prostitution. Through its participation in several rescue missions of children held in brothels, FFW came to realize that many of the girls were of rural and tribal origin.

Girls who have been involved in prostitution often return to the villages looking elegant and well dressed and with money for their families. The girls do not tell their families what they have had to do to acquire their 'riches' and the villagers are left with the impression that they have found good jobs in the city. As a consequence, additional village girls are lured into seeking work in the city expecting employment as waitresses or bar attendants but ending up trapped into prostitution.

Experience showed that law enforcement was insufficient to stem the tide of child prostitution and help these young women. FFW decided to launch the Kamla project as an educational campaign in the rural areas, taking advantage of the knowledge accumulated through its media campaign for women. 'Kamla' (a girl's name) was written as a textbook for children aged between 12 and 14 from the northern provinces of Thailand in the last grades of primary school – the time of highest risk for entry into child prostitution. The target audience also includes primary school teachers, government outreach workers, and village leaders. 'Kamla' is based on true stories of northern village girls who were deceived, lured into prostitution, and finally died in a fire in a brothel.

The Foundation for Women followed a scientific and systematic approach in designing the Kamla project. The artwork, wording and contents were developed in conjunction with girls and teachers from the northern provinces through pre-tests conducted in schools. After the first distribution of the book, a random survey was conducted to evaluate the impact and use of the publication.

In response to the book, local teachers expressed their desire to assist girls whom they knew would turn to prostitution. Lacking funding and training, they were eager to enter into partnership with FFW. To develop support networks, FFW began conducting seminars with primary school teachers who had used the book to allow them to share and systematize their techniques and experiences. A Kamla newsletter was launched to disseminate information and maintain contact with the teachers.

As a result of the evaluations, FFW revised the Kamla book, giving special attention to the recommendation to make the project action-oriented. The revised version of the book thus includes:

- guidelines for classroom discussion
- a list of vocabulary which the girls should be aware of to help protect themselves
- a list of common STDs
- the addresses of governmental, non-governmental and religious organizations where young women can seek assistance. One of the strongest messages of the book is that prostitution is not the girl's fault and that there are ways that a girl can protect herself.

FFW also realized that the Kamla project had to offer a viable alternative to girls who would be forced financially to search for work in the city. A scholarship fund was therefore developed to support girls who completed their primary education. The 'Weaving New Life' project was established as a loan fund to support women's groups who initiated income-generation projects that employ young women in their villages.

A second book on child prostitution was produced for children in the north-east part of Thailand. FFW felt the need to produce a separate book not only because of the particular cultural realities of the north-east, but also because of the different strategies used by pimps to recruit these girls. In the north-east, the common approach is to recruit the girls into factory work before transferring them into prostitution. The original text of the book 'Kamkaew' was written by a north-eastern girl while she sought refuge in the Home for Battered Women. The young woman was inspired to share her story to prevent other women from suffering the same fate.

In addition to the textbooks, FFW produces materials for general distribution to educate individuals about the recruiting and procuring methods of pimps. Through calendars and audio-visual materials, teachers and children share their experiences and suggestions. The seminar series

has grown to include special activities on male–female relationships, sex stereotyping, and the portrayal of women in the media. Male teachers in the north-east were inspired to form men's groups to work to alter the sexist attitudes of men in Thai society. Study tours are conducted with teachers from the rural areas to enable them to see first hand the 'red-light' districts and sex resorts. At the national level, teachers are participating in conferences and FFW representatives are working to amend laws against child prostitution and to improve enforcement.

The Kamla project has proven to be a catalyst in generating local action and awareness to end trafficking in child prostitution. An estimated 6,000 schoolchildren had benefited from the programmes initiated by teachers as of 1990. The key factors that contributed to the tremendous success of the project were the scientific approach taken in developing the textbooks and the emphasis on involving the community in all facets of the project.

Model programme
ECPAT (End Child Prostitution, Child Pornography and the Trafficking of Children for Sexual Services): Legislation against cross-border sexual exploitation of children; Worldwide network

The Commercial Sexual Exploitation of Children (CSEC) comprises child prostitution, child pornography and the trafficking of children for sexual purposes both nationally and internationally. CSEC includes the phenomenon of 'child-sex tourism'. Child-sex tourism is said to have grown during recent decades due to increased travel and tourism which has made it possible for people to travel easily to regions where children are inexpensively available for sexual services.

ECPAT (End Child Prostitution, Pornography and the Trafficking of Children for Sexual Services) is a network of national coalitions of NGOs and individuals concerned with the commercial sexual exploitation of children. The ECPAT campaign, when it was formed in 1990, initially stood for 'End Child Prostitution in Asian Tourism' and focused initially on the link between prostitution of children and tourism, and promoted political action, law reforms, education and media coverage of the issue.

After the 1996 World Congress Against the Commercial and Sexual Exploitation of Children which was organized by ECPAT, UNICEF and the NGO Committee on the Rights of the Child, ECPAT's scope broadened to include all children exploited in the commercial sex industry (including prostitution, pornography and trafficking of children). In 1998 there are over 250 groups in the coalitions which form the ECPAT network, in about 30 countries.

ECPAT's particular success has been in mobilizing the press and media to raise awareness to unprecedented levels. It has also been successful in

promoting transnational government co-operation, extra-territorial legislation which allows governments to bring their nationals to trial for crimes committed in other countries, and in drawing public attention to the arrest, detention and conviction of child abusers engaged in sex tourism.

In Asia, notably in Thailand, the Philippines and Sri Lanka, ECPAT has successfully lobbied for the introduction of new legislation or amendments to old legislation that give stricter penalties to exploiters. In tourist-sending countries ECPAT lobbied for the introduction of extra-territorial legislation – which will allow the prosecution in their home country of an abuser who sexually exploits a child when overseas.

In the countries where the legislation has been changed (e.g. The Netherlands, Australia, Brazil and the UK) the ECPAT groups are now focusing on law enforcement through awareness-raising activities such as leaflets and posters. Training-pack campaigns for travellers and the tourism industry Codes of Conduct are also being promoted (for example, in Australia). ECPAT has also worked for the promotion of bilateral agreements or Memorandums of Understanding between countries to promote co-operation and police training. For example, the Philippines has signed such an agreement with both Australia (August 1997) and the UK (September 1997).

ECPAT's training efforts have also focused on law enforcement and judiciary personnel to ensure that children involved in prostitution are treated as victims not as criminals. Research is being carried out on best practices for law enforcement and judiciary on extra-territorial cases.

The NGOs that are members of ECPAT are working on the issue of the trafficking of children for sexual purposes and have set up centres for those children who can return to their communities. They also offer vocational training to give children a means to earn their livelihood, counselling and other services. But staff have found the recovery and reintegration of children involved in prostitution to be very complex work, with some communities finding it difficult to accept returning children, and consequently, NGOs are needed to help integrate these children into new communities.

The ECPAT group in the UK has initiated a pilot project to set up national youth campaigns with the aim of encouraging young people to participate in the debate on CSEC at regional, national and international levels. The pilot project is working with a group of young people who have produced a campaign film on CSEC explaining the issue 'in their own words' to other young people in the UK and encouraging them to take action. The film will be accompanied by a campaign information pack which will be distributed to youth groups across the country. It is hoped the project will be replicated across Europe and will form the basis of a network of young people campaigning on the issue.

Model programme
Inter-African Committee on Traditional Practices Affecting the Health of Women and Children: Confronting harmful traditions

Female genital mutilation (FGM), the ritual of cutting off a young woman's clitoris or external genitalia, is estimated to affect about 130 million girls and women worldwide (Alan Guttmacher Institute, 1998). The practice is regularly performed in some 26 African countries (and in a few countries in Asia and the Middle East) on about 2 million young girls and women per year. In Sudan and in Mali, 87 to 93 per cent of young married women aged between 15 and 19 have been cut. The age at which a young woman typically undergoes the procedure varies across cultures. However, cutting most commonly occurs when a girl is between the ages of 4 and 12 (Toubia, 1995 *cited in* Alan Guttmacher Institute, 1998).

The two most common types are clitoridectomy and excision and they account for roughly 85 per cent of all the cases. In clitoridectomy, part or all of the clitoris is removed, while in excision both the clitoris and the labia minora are removed. The severest form of FGM is infibulation, in which all of the clitoris and some of the labia minora are removed and an incision is made in the labia majora. The sides of the vulva are sewn together leaving only a small opening for urination and menstruation. This procedure accounts for 15 per cent of female mutilation.

Essentially, female genital mutilation is a long-standing tradition in many societies, which is recognized and accepted as a ritual that marks the transition to adulthood. In these societies it is considered an important means for the socialization of women, curbing their sexual appetites and preparing them for marriage. Muslims, Christians, some animists and one Jewish sect are among the diverse religious groups on the African continent that practise it (Alan Guttmacher Institute, 1998).

The health consequences of FGM can be severe. In Sudan, for example, approximately 10 per cent to one third of all girls in areas where antibiotics are not available will die as a consequence of the procedure. Other immediate complications include haemorrhaging, shock and infection. Subsequent complications can include repeated urinary tract infections and painful menses and sexual relations. Complications during childbirth can include prolonged labour and vesico-vaginal or recto-vaginal fistulae (a tear between the vagina and urinary tract or anus resulting in incontinence and social rejection).

For many years, FGM was considered too culturally sensitive to address as a human rights issue. Gradually, however, various UN committees and the World Health Organization pointed out the health implications of these practices and the fact that FGM is frequently performed without voluntary

consent. Others have pointed out that 'voluntary consent' is difficult to obtain in an environment where a form of condoned mutilation is the social norm.

In 1984, the Inter-African Committee on Traditional Practices Affecting the Health of Women and Children (IAC) was formed. Its mission is to eliminate harmful practices such as early childhood marriage, FGM, male-child preference and nutritional taboos. The IAC's main mode of operation is the creation of national committees, which so far have been formed in 20 countries. At the local level these committees work to sensitize opinion-makers, religious leaders, political leaders and the general public about the harmful effects of certain traditional practices, particularly FGM. These national committees co-ordinate activities such as information campaigns, curriculum development and the retraining of health personnel and traditional birth attendants (who generally perform or enforce harmful traditional practices).

IAC, as the umbrella organization, co-ordinates regional activities and promotes networking and the sharing of lessons learned through regional meetings. It serves as a liaison to international organizations to insure attention to the issue at the international level, and has affiliates in parts of Europe, where a number of immigrant groups who practice FGM live.

At the local level, specific activities of the committees include collaboration with youth groups and health professionals to present skits, develop publications or use anatomical models at various local and national meetings to show the physical effects of FGM. In Sierra Leone, for example, the local committee works with 'secret circumcision societies' which perpetuate the practice to educate them about the harmful effects of FGM and to emphasize that traditional rites of passage ceremonies can continue intact without including FGM.

One of main strengths of the IAC is that it relies on African women, many of them opinion-leaders or prominent health professionals in their countries, to lead campaigns. While the movement has faced major obstacles – including threats of violence from groups which seek to perpetuate FGM – they have gained access to local policy-makers and have sought to emphasize the positive aspects of traditional culture while seeking to abolish the negative aspects.

Model programme
Heart-to-Heart: Preventing sexual abuse among adolescent mothers and their children; Chicago, USA

> *'For girls, I think they don't give a care if they are alive because they get sexually abused and they will go around just jumping into any other guy's bed. After it happens they feel so cheap and fleezy [sic] and they*

don't care about life anymore. They are hurting me, so why shouldn't I hurt myself.'

(Teenage mother, USA)

The Ounce of Prevention Fund in Chicago, Illinois, USA, works with adolescent mothers and their families providing an array of support services, including home-visiting, group services, vocational training and support, childcare and medical services amongst others. In 1986, a state-wide survey of programme participation conducted in collaboration with Ounce of Prevention revealed that nearly two-thirds of teenage mothers interviewed had at least one coercive sexual experience prior to their first pregnancy, nearly one-third by a family member. The average age at first sexual abuse was 11.5 years.

Responding to this alarming statistic, the Ounce of Prevention developed the 'Heart-to-Heart' programme, a community-based project which has as its goal improving the capacities of adolescent mothers to protect themselves and their children from sexual and other types of abuse. In a specially designed 12-week curriculum, group members (teenage mothers) learn about and discuss such issues as: the prevention of sexual abuse; social, emotional and sexual development; victimization; indicators and law about abuse; communicating respect to children; forming healthy relationships; and developmental interruptions due to past abuse. Discussion of the young parent's own sexual socialization, and past and current relationships with males are core features of this curriculum.

The centrepiece of Heart-to-Heart is the process of journal writing which encourages girls to reflect on their own sexual histories as well as present and past interpersonal relationships. The journal provides a place for private thoughts, and may include written interaction between the writer (teenage parent) and a professional (group facilitator) who writes comments about their journal entries. If either the journal or group discussion reveal distressing situations about abuse, appropriate referrals and interventions take place.

'In writing, an adolescent girl has the opportunity to tell her story – her personal history as she perceives it. Such an enterprise is more than self-expressive; it is self enhancing, promoting a sense of mastery over the events of her life.'

(Musick, 1993)

Specifically, the journals provide an opportunity for young parents to:

o build their self-confidence
o develop their creativity
o learn to express themselves
o examine, understand and express their feelings

- ask for help in a way that is not embarrassing
- practise reading and writing (and perhaps promote literacy).

The outcomes of the journal methodology have been impressive. In some cases, the journal process was the first time that the young women disclosed and discussed – and learned how to cope with – a past incident of sexual abuse. The project has also helped teenage mothers to avoid or end relationships with men that were harmful to their children, and to better understand and act on indicators of abuse.

The journal methodology used by Heart-to-Heart has the added benefit that it serves the staff who work with the young parents by giving them more information on the social forces and psychological themes that motivate and guide their behaviour.

Elements of success: Advocacy and rights

In reviewing the successes of these programmes working to protect the rights of young women, a number of lessons stand out.

Making the maximum use of existing laws and legislation
ECPAT, the Kamla Project and the Heart-to-Heart project all work to raise awareness about existing laws against the exploitation of young women. In many cases, laws exist to protect the rights of young women but they are unknown or remain unenforced. These programmes have recognized the power of knowing the law.

Seeking policy changes on an international level
In the cases of young women or girls exploited through prostitution, particularly in Asia, the abusers are often sex tourists. In the case of female genital mutilation, parents of young women from immigrant groups who maintain the practice in France or England have sought to send their daughters back to the country of origin to be excised. In both of these examples, advocacy efforts are required across boundaries.

Involving young women as actors
The Heart-to-Heart project learned the power of involving young mothers to prevent abuse of their own children. In addition, many of the counsellors and staff on the project were themselves adolescent mothers or victims of sexual abuse. Similarly, the Kamla project has worked with victims of sexual exploitation who wanted to educate their peers.

Working at a variety of levels
All the programmes mentioned have seen the need to work at a variety of levels to reach policy-makers, the media, the families of young women, the

school system and young women themselves with messages about their rights. These programmes have learned that working at any single level is not as effective. In essence, these programmes have sought to create networks of protection.

7. Involving Boys and Men in Efforts to Improve Young Women's Lives

'It is hard to talk about emotions. I keep to myself. I have doubts and fears, but I don't talk about them. I have never talked about my emotions,'
(Teenage boy in focus group in Rio de Janeiro, Brazil, *quoted in* Loewenstein and Barker, 1998)

'The more attention we pay to the issue of masculine identity, the more we realize how much changing societies demand of young men. They must be strong, brave, and in control. Yet at the same time, we ask them to be sensitive and not to become violent or unemotional. It is not surprising that they feel confused and conflicted about their proper role.'
(Simonetti, Simonetti & Arruda, 1995)

Introduction

THE PROGRAMMES DESCRIBED in this book have the common mission of transforming the lives of young women in difficult circumstances, either by providing direct services, or through advocacy and public-education efforts. In recent years there has been growing recognition that improving the lives of young women, individually and collectively, cannot truly be achieved without changing the attitudes of men – and how they treat, view, and interact with young women. A number of the programmes included in this book – among them, Casa de Passagem, the Women's Centre in Jamaica and the Ounce of Prevention Fund in the USA – told the authors about examples of work to empower young women which has been undermined by men who continued to view these young women in detrimental ways.

In order to empower young women and give them self-agency, we must change the environment in which they live, work and carry out their personal lives. For many years, 'gender' as a topic has focused on women; now researchers, advocates and programme planners are discussing it as a concept that applies to both sexes.

An emerging body of research on men and men's attitudes – from Latin America, Western Europe and North America, but with important examples from Asia and sub-Saharan Africa – has offered important insights into how masculinity and patriarchy, or male dominance, is constructed in societies and reconstructed in the lives of individuals. Research in Brazil, for example has concluded that young men and low-income men who are outside the dominant social classes are subjugated, as are women in patriarchal settings in which adult and upper-middle-class men are the

unquestioned authorities. Indeed, men of all social classes are subject to social systems that proscribe and enforce what is acceptable behaviour as 'real men' (Nolasco, 1995; Barker & Loewenstein, 1997). This emerging research has also helped us understand that not all men exploit or sexually abuse women or deny them opportunities. Masculinity is not, as it is sometimes presented, synonymous with violence and discrimination against women.

These new perspectives on gender have important ramifications for our work with young women and with disadvantaged young people in general, one of which is a movement away from the tendency to compare by sex in order to determine who suffers most because of social disadvantage and poverty. In the field of at-risk or disadvantaged young people, a number of advocates have suggested that instead of worrying so much about which sex is most victimized or most affected by certain issues, the more relevant question should be: 'How do boys and girls suffer or confront disadvantage in different ways because of their gender?'.

In looking at the issue of early childbearing, we should not assume that early childbearing and men's lack of involvement in caring for children is without consequences for young men as well as young women. An emerging body of literature has shown that some men want to be more involved with their children but face barriers, primarily related to their inability to secure adequate employment (*see for example,* Brown et al., 1995). As we call attention to the difficult circumstances facing urban girls we should be careful not to make it seem as if their brothers – who are often themselves street or working boys – are doing fine.

This chapter is organized slightly differently than the other chapters in this book because the programme experiences are still emerging, and because there are few programmes that are specifically dedicated to working in gender equity with adolescent boys. Thus, this chapter presents general reflections and lessons learned from programmes working in a variety of themes with adolescent boys.

Reflections on working with adolescent boys in the reproductive-health field

The family-planning and reproductive-health field may be the furthest ahead in terms of incorporating this new gender paradigm into its programmes and policies. Most thoughtful family-planning programmes recognized early on that men had to be included in these efforts. The following conclusions have been reached by various programmes.

Like women and girls, boys and men need holistic services
A number of family-planning programmes, like Profamilia (the Colombian affiliate of the International Planned Parenthood Federation) have con-

cluded that even if one of its overriding goals continues to be involving men in improving women's lives, they must understand and treat men holistically (AVSC International, 1997c).

Profamilia and a number of other NGOs are beginning to offer insights on how to involve young men in the area of reproductive health. Some lessons learned include recognition of the need to provide for men's needs beyond family planning – for example, by providing STD treatment, which has worked to attract men in clinic sites around the world. Profamilia in Colombia has found that offering an array of services ranging from relationship-related counselling to general health services can attract large numbers of men and has helped its services for men to become financially self-sufficient.

Even where gender roles are apparently rigid, there are young men who can be reached with gender equity messages

Some reproductive health organizations, like the Family Planning Association of Pakistan, found that even in areas where family planning was not widely accepted by men, it is possible to work with a few 'converted' or progressive men to reach other men. For example, by working with men who accept reproductive-health responsibility along with their wives they could reach and persuade other men to do the same. Other programmes have attempted to reach local leaders, including religious, village and political leaders, to present a male-involvement message (AVSC International, 1997a; Barker, 1997).

The need to work with young men early on when values about relationships and sexuality are forming

There is ample research confirming the fact that gender roles are rehearsed and confirmed during adolescence, providing a strong theoretical basis for working with young men (*see* Erikson, 1968; Archer, 1984). Empirical research suggests that early sexual habits and patterns of interaction in intimate relationships form the basis of lifelong habits and patterns. Research in the US, for example, has found that males who started sexual activity later were more likely to use condoms and those who used condoms during their first sexual relations were more likely to use condoms consistently thereafter (Sonenstein et al., 1995). Qualitative accounts of the early sexual activity of adolescent males in Latin America and sub-Saharan Africa would suggest a pattern of viewing women as sexual objects. Furthermore, the use of coercion in obtaining sex and viewing sex from a performance-oriented perspective begin in adolescence with early sexual activity and often continue into adulthood (*see, for example,* Bledsoe and Cohen, 1993; Shepard, 1996).

Reflections on involving men in the prevention of domestic violence

Limited research from Africa and Latin America confirms that many men see domestic violence as part of an informal marriage or cohabitation contract (*see* Ali, 1995; Brown et al., 1995; Njovana and Watts, 1996; Barker and Loewenstein, 1997). We also know that other men often condone this violence, providing mutual support for each other. Although a growing body of research has revealed the extent of men's violence against women, it has offered little insight into how to work with men to prevent domestic violence and sexual coercion. Very few studies have asked men what they think about the issue, or about their own experiences of having been violent. While more than 400 organizations are currently working to reduce violence against women just in Latin America and the Caribbean (World Bank, 1993), few have worked with men to promote alternative gender roles and prevent male violence towards women.

The following models of intervention represent a few of the emerging programme responses to male violence.

Therapy

In North America and Western Europe, discussion groups in schools and universities have sought to raise awareness about and prevent some forms of sexual coercion and domestic or dating violence. In some Western European countries and in parts of North America, men who have been abusive, either physically or sexually, are required to participate in court-ordered therapy, including group therapy.

Group discussion and support

Even more promising and relevant, from a developing country perspective, however, are voluntary discussion groups in which men have a chance to discuss their past acts of violence or their desire not to be violent. Such discussion groups are beginning to appear in Latin America. In Mexico, an NGO called CORIAC, using a methodology adapted from ManAlive (a men's movement to prevent violence, based in the USA), has started voluntary discussion groups for men who have been violent in their relationships. After about eight months of participating in the group, these men in turn become facilitators of additional discussion groups (Barker, 1997). In Brazil, NGOs have carried out research with adolescent males on their attitudes related to violence against women, and incorporated suggestions about preventing this violence in its sex-education activities (Barker and Loewenstein, 1997).

For the most part, in developing countries, work with men in preventing domestic violence continues to focus on raising awareness and developing policies to assist women who have been abused. In general, programmes

which work with men to discuss the issue are few in number and more are urgently needed if we truly hope to prevent domestic violence and sexual coercion.

Programme examples in working with adolescent boys

Although programme examples for working with adolescent boys are only just emerging, there are, nonetheless, a number that offer some insight on reaching adolescent boys to work in gender equity.

Case study
The experience of SIDH in India: Working with boys in regions where gender roles are apparently rigid

An NGO called SIDH in the Himalayas region of India has long worked in integrated rural and community development, and has sought to detect and take advantage of cracks in the patriarchal system. Even in remote, rural areas, project staff have found that it is possible to find a few 'progressive' men, men who help their wives when they are ill or assist in unusual ways during childbirth. Consequently, one strategy of the project has been to encourage these few 'good' men to 'go public' with their alternative viewpoints (telephone interview, Elaine Murphy).

One important strategy of the SIDH project is to include issues that the local population finds important, as part of its educational workshops on gender issues. This strategy minimizes any possible backlash, and makes the programme more responsive to local needs. SIDH project staff were similarly flexible in gathering baseline data. When 'formal' research methods – focus-group discussions or individual interviews – did not work because of local cultural norms, the staff used other research methods that helped to find 'cracks' in the patriarchal system and offered some ideas for identifying the 'few good men'. These methods included observation of the community and group interviews that used drawings.

Furthermore, before training the local trainers, SIDH staff recognized the importance of having gender-sensitization workshops with the staff themselves, realizing that a process of changing gender norms would not be possible unless staff themselves understood and reflected on their own values.

Case study
ECOS's experience in Brazil: An example of targeting gender equity and reproductive health information to adolescent boys

One NGO in Brazil has found the need to work with men in locations where they naturally hang out, to engage them on multiple fronts and to

help men develop a critical stance toward prevailing models of masculinity. ECOS[1] in Brazil has learned that is it is necessary to question the traditional, patriarchal system in small doses and with various methodologies, and therefore uses workshops, videos, drawings, anatomical models, and newsletters.

ECOS starts off its discussion sessions with young men addressing the themes they want to discuss, and using those themes as a port of entry into the theme of gender equity. ECOS has provided these sessions at the workplaces of adult and adolescent men and has found strong receptivity; however, they note that employers who invited ECOS in to work with the men have the impression that the issue of gender equity and men's needs are 'resolved' in one session. Individuals collaborating with ECOS have confirmed the importance of taking the programme activities to young men – to places like union meeting halls, neighbourhood associations and soccer clubs.

In other discussion sessions, ECOS staff have worked to help men see the harm of the violence that is part of their socialization – for example, reflecting about the violence found in boys' games. In workshops, men discuss how they participate in violence against women and other men, and against themselves. These workshops have helped young and adult men develop the ability to be self-critical and reflective and to understand how men sometimes use violence as a way of affirming their masculinity.

Case study
The experience of the Ounce of Prevention Fund in the USA: Adapting programmes for adolescent girls to include adolescent boys

The Ounce of Prevention Fund in the USA, which developed the Heart-to-Heart Programme featured in Chapter 6, has found the need to use older male role-models or mentors to present versions of progressive masculinity, and has created male responsibility groups as part of adolescent health clinics where it works. At one high school in a low-income neighbourhood where the Ounce of Prevention Fund works, the success of the male-responsibility group lies in the fact that it provides a space where young men can reflect about themselves and who they want to be or where they want to go, and have the chance to learn from capable same-sex role models whose relationship they value.

The programme has attracted a stable group of young men who seek to

[1] ECOS in Sao Paolo Brazil is an NGO that has been working more than 10 years in reproductive health and sexuality in the production of education and training materials, carrying out research and advocacy campaigns, and providing training in the area of sexuality, gender awareness and reproductive health.

'do the right thing' in their relationships with young women in large part because the young men interact with older males who model progressive versions of masculinity, and create a group identity as responsible young men. The male-responsibility group questions the stereotypical model of low-income African-American men as irresponsible and unsuccessful and instead identifies and celebrates examples of responsible, successful African-American men. Membership of the male-responsibility group implies to some extent an acceptance of this model of 'responsible' manhood – one who fulfils his obligations in relationships with women and others around him. The group leader stresses punctuality and following through on promises in all realms of life – including in relationships with young women.

The Ounce of Prevention Fund has also used its Heart-to-Heart curriculum (originally intended for working with adolescent mothers and adolescent women who have been victims of abuse) to work with adolescent boys. Boys participating in the curriculum became aware of young men's sometimes abusive attitudes toward young women, but also began to discuss to a greater extent their own experiences with violence and abuse. Staff at the programme have come to see that just as young women need a space to discuss and reappropriate their life histories, young men in at-risk settings often need the same opportunity.

Lessons learned from work with adolescent males in gender equity

In reviewing these programme experiences, the following are specific programme examples and lessons learned from work with adolescent males in gender equity.

Schools are one of the best avenues for reaching young men

In reaching adolescent males, and even pre-adolescent males, the school system is one of the best means of presenting a message of gender equity. Indeed, a number of NGOs in Latin America, such as ECOS in Brazil and Salud y Genero in Mexico, have sought to use schools in this way. Teachers and other school staff can also be important allies in presenting more egalitarian gender roles through their interaction with students and as part of sexuality education programmes. As a staff member of Salud y Genero put it: 'The school is an environment where one confronts, conforms to, learns and practises gender relations. Therefore the school is a good scenario for deactivating sexist education and socialization and discovering the values of egalitarian relationships' (Keijzer, 1995).

These programmes could also incorporate a more extensive critique of gender, including ideas for deconstructing patriarchal masculinities, especially where family-life education or sex education has been incorporated into public school systems (such as in parts of sub-Saharan Africa) or

where it is offered outside school systems (such as through CEDPA's Better Life for Young Women programme and numerous NGOs).

The need to influence social norms before they take hold

Various organizations working with young men on reproductive health issues and sexuality have concluded that adolescents need more than just knowledge to change their attitudes; they also need:

o experiential learning processes using role plays
o values-exploration activities
o peer promoters, with slightly older males working with younger males.

The need for services targeted at boys' own needs

Many service providers working with adolescent males have recognized that their programming should not simply be adaptations of adult, women's or adolescent women's programmes (Armstrong, 1986). Other NGOs, including one in Brazil, have highlighted the need to develop special programmes to assist low income and out-of-school young men, for whom violent forms of masculinity may be even more common and on whom economic difficulties fall the hardest (*see* Barker and Loewenstein, 1997). Similarly, the Ounce of Prevention Fund found that although boys could be engaged in discussing their potentially abusive attitudes toward young women they also had their own concerns and needs – including victimization by abuse and violence – that they needed to discuss.

The need to help boys overcome their difficulty in expressing emotions

A number of NGOs working with young men have found that they have difficulty expressing themselves orally, or expressing emotions generally. One NGO in Brazil that works with young men and adult fathers has used artistic expression as a way for men to express their feelings about parenting, children and their relationships with women and CORIAC in Mexico has used photo essays to do so.

Conclusions

Many NGOs working with young men tell of difficulties they initially faced in persuading them to open up, of getting them to show up for group activities and of their apparent initial lack of interest in discussing issues related to sexuality, domestic violence, health and fatherhood. Nonetheless, groups like ECOS in Brazil, Salud y Genero in Mexico and SIDH in India have generated and tested numerous ideas and methodologies that encourage adolescent males to talk about such issues. All these organizations have also been carrying out gender training with teachers and other

individuals working with youth and have been grappling with the complicated issue of how to support young men who already question traditional gender roles but feel pressure from their peers and family to behave in traditional ways.

What is missing from the experience with adolescent males, however, is better evaluation of gender-education programmes to know what works to change attitudes, as well as a forum or means to exchange information among organizations around the world that are working with adolescent males.

Most of the programmes working with young men have found that with creativity and sensitivity towards the alternative ways that young men express themselves, it is possible to engage them in discussions about the way they treat and interact with women. Indeed, many of these programmes find that young men are often relieved at being able to abandon an outdated, rigid and often *machista* or callous way of being men.

However, these programmes have faced a number of barriers. One is that because they are new, funders are not yet convinced of the efficacy of gender sensitization or gender equity training groups. Another barrier is the attitudes of staff, particularly in those organizations that have a history of advocating on behalf of young women. Front-line staff who have built their professional identities around defending young women sometimes find it difficult to work with and on behalf of the young men they perceive (often with good reason) as having victimized women.

8. Conclusions

IN REVIEWING THE programmes included in this publication, it is clear that only a small proportion of urban adolescent women in need are being reached. The majority of the programmes are relatively young and are still developing their strategies. Nevertheless, a number of important conclusions emerge as to where and how efforts should be directed in the future. Broadly speaking, these conclusions can be divided into two categories:

- *advocacy recommendations* on how to draw more attention to the needs of urban adolescent women and, hence, increase the level of services; and
- *service recommendations* on the kinds of services and attention that young women need.

Advocacy recommendations

Disaggregate national statistics and data by age and sex

In many cases, the needs of girls and adolescent women as measured by statistics related to health and social services are not known because data are not disaggregated by age and sex. One concrete step to help governments better understand the dimensions of the problems facing urban adolescent women is to disaggregate national demographic and health statistics by sex and age.

Conduct research on specific topics related to the needs of urban adolescent women

For many girls and young women in difficult circumstances – particularly women in domestic work and young women exploited through prostitution – relatively little information is available on the number of young women involved in such situations or about their backgrounds and their working conditions. On other topics such as sexual abuse and abortion there is little information available due to their taboo nature and efforts to hide them. While gathering data on these populations can be difficult and time-consuming, it is by no means impossible. Numerous research techniques are being pioneered – including qualitative techniques or targeting selected 'captive' populations – that are extremely useful for this kind of research. What is lacking is the political will to openly conduct research on taboo topics and exploited populations.

Develop mechanisms for exchange of information and lessons learned

Many of the programmes contacted for this publication mentioned the need for a forum in which to exchange information on their programmes. Indeed, the programmes contacted were eager to share and to hear about lessons learned from other programmes working with at-risk young women. In addition, the striking similarities regarding the problems facing urban adolescent women across cultural and country boundaries point to the fact that programmes could learn much from each other and replicate programmatic elements if opportunities were provided for exchange of information. This exchange should be more than just paper flow; programmes should have opportunities to visit each other's projects.

Direct special attention to the needs of 'hidden' populations

In reviewing the information from programmes contacted for this publication, it is clear that young women in domestic work receive less programmatic recognition than any other at-risk group. Part of this is due to the difficulty of reaching live-in domestics who are often behind closed doors. In addition, talking about the needs, problems and often exploitative working conditions of domestics is a sensitive issue due to its widespread practice.

Direct attention to the 'abusers'

In too many cases, programmes are designed to 'rehabilitate' young women in prostitution or help the victims of abuse, without efforts to address the 'demand'. In the case of adolescent mothers, sex education and prevention should also include young men (and adult men, in many cases). For efforts to assist domestic workers, the employers should be educated about the rights of their employees. In the case of the commercial sexual exploitation of minors, pressure – including criminal penalties – should be applied to those who provide the demand. In the course of gathering information for this publication, only a handful of programmes were mentioned that sought to stigmatize or put pressure on the men who sexually exploit young women.

Assist existing leaders

In many cases, natural leaders already exist to carry out some of the advocacy-related tasks listed here. Some of these leaders may be directors of programmes; others may be young women themselves. In many cases, strengthening the position of and providing individual support to these leaders can go a long way to improving the overall situation of at-risk young women. Special attention should be given to training and education for female educators and counsellors for adolescent women.

Include young women as a separate and distinct focus of attention within efforts to assist women and children

Young women should be included as part of broader efforts and development agendas to assist both women and children. However, they should be given their own separate and distinct agenda within these movements. In the family-planning field, for example, many programmes have tried to include young women within their overall efforts without providing special services or attention. The result is that young women did not make use of the service. When adolescent women are not given special attention within the women's or children's agenda with regard to research or advocacy, they are usually lost in the process. The needs and realities of adolescent women – while sharing many similarities with adult women and with children – are distinct and should be treated as such.

Lobby governments to address the needs of young women

With a few notable exceptions, it is primarily non-governmental organizations who are addressing the needs of at-risk urban adolescent women. Governments are largely failing to do their share. One way to convince governments of the need to assist young women is through research clearly showing their needs. Another is to persuade governments that investing in young women is cost-effective and important. Similarly, studies could help show governments how much not providing services to this population costs them in terms of school drop-out or health costs associated with abortions and high-risk births to adolescent mothers, for example.

Persuade donors to offer venture capital to experiment with new programme models

Efforts to assist young women in difficult circumstances are still new and pioneering. To avoid replicating traditional models (particularly in the area of income generation) projects need funds to experiment with new programme models. Donors must have the patience to recognize that some of these efforts – in the name of experimentation – will fail but that the learning process in itself is needed.

Service recommendations

In addition to these advocacy recommendations, there are a number of conclusions regarding the service needs of at-risk urban adolescent women.

Establish a primary relationship

Nearly every programme contacted for this publication mentioned establishing a primary relationship with young women as the first step in assisting them. In many cases, young women in difficult circumstances have been cut off from their family. Before issues related to education or

vocational training can be discussed, programmes must establish a relationship of support and trust, with the end-goal being to improve the young woman's self-esteem.

Develop a caring and consistent environment that provides space in which to reflect

As previously discussed, many young women who are separated from their family establish self-destructive relationships or habits on the street or in other settings. Before moving out of these destructive settings, young women often need a space to reflect and come to the conclusion on their own that they are ready to move on.

Provide training in non-traditional skills

Far too many projects train young women in gender-stereotyped activities such as sewing or cooking. While these skills can sometimes be useful for income generation there are many options of non-traditional skills training or income-generation projects that are never included. In many cases, programmes need to learn to be responsive to the expressed demand of the market-place. Other programmes have learned that they should provide vocational training in more than one field, given the volatility of the job market.

Teach business skills and positive work habits

Many programmes have learned that it is not enough to provide skills in a particular trade. Programmes must also work with young women to provide skills in business management and positive work or personal hygiene habits that would enable them to find a non-exploitative job.

Provide family planning, and AIDS-prevention and sex education

Many programmes and governmental agencies are unwilling to provide frank and accurate sex education and contraceptives, including condoms. Sometimes programmes use the false excuse (as proven in numerous studies) that talking about sex education and family planning encourages sexual activity. Other programmes are uncomfortable or unwilling to accept the sexual lives of adolescent women. Until such taboos and obstacles are openly addressed, young women in difficult circumstances will continue to seek unsafe abortions and continue to be at high risk for HIV/AIDS and other sexually transmitted diseases, which, in turn, lead to higher risk for cervical cancer and infertility.

Use current health problems to promote prevention

By the nature of their lives – on the streets, in brothels, etc. – young women in difficult circumstances are often reluctant to take preventive measures regarding their health. A number of programmes have learned to use actual

health problems – an unwanted pregnancy or a STD – to promote prevention. While efforts should continue to be made regarding primary prevention, in many cases, it is current health problems or issues that provide opportunities for secondary prevention.

Make use of peer promotion

In many cases related to health and other problems, peer promoters or youth multipliers provide excellent sources of information and preliminary counselling for young women. At present, many young women rely on misinformation from their peers about health issues. When armed with accurate information, young women can make excellent educators and counsellors for their peers. Often, young women need extensive and time-intensive training until they have the capability to be leaders. Many programmes lose patience, but experience has shown that the effort in training and working with young women to assist their peers is worth the effort.

Strengthen programme aspects related to culture

One of the weakest programmatic elements of many of the programmes working with at-risk young women are those related to strengthening local culture. Frequently, the situations that lead urban young women to face difficulties – such as migration to cities, for example – are related to the breakdown of traditional cultures. Programmes working with young women should strive whenever possible to include elements and projects which restore value and encourage reflection related to the positive aspects of traditional culture. Programmes could also make use of elders or the elderly to provide a link to traditional culture.

Build self-esteem and a sense of future

Along with building a primary relationship, improving a sense of self is one of the first steps in helping young women in difficult circumstances. This task must also include providing skills and technology that give young women a sense of power in their lives. Building self-esteem also requires helping young women build a project or a trajectory for their lives with a positive sense of a future. With regard to early pregnancies, for example, a healthy sense of a future combined with accurate reproductive-health information – and family-planning services – is probably the strongest means of prevention.

Educate to provide skills for real life

Educational programmes for young women in difficult circumstances should be carefully tailored to provide practical living skills. Issues such as managing money, maternal and child health, where and how to look for a job, basic nutrition and cooking are often more important – at least in the

short run – than the academic subjects into which young women are often channelled.

Reconnect young women with their communities and families

The needs of urban adolescent women are the needs of communities and families – not just of individuals. In their efforts to protect young women, programmes frequently isolate young women from their communities and families. When it is not possible for young women to return to their families, programmes should seek to develop ties with elders from the same community or racial or ethnic group, or with extended family members who can provide guidance and a nurturing environment.

Looking to the future

Investing in at-risk girls and young women is vitally important for the welfare of society. Despite the evidence of endemic exploitation and discrimination, the programmes highlighted in this study give reason for hope. Organizations like Servol, Casa de Passagem, the Undugu Society, Kamla and dozens of others have broken new ground in responding to the needs of these young women. Not only have they developed programmes to address their immediate needs, but they have also attempted to empower young women with the knowledge and skills to tackle the root causes of these problems. The challenge now is to build on these initiatives.

References and Bibliography

Advocates for Youth (1989) *Adolescents, AIDS and the Human Immunodeficiency Virus: The Facts*, Washington, DC: Advocates for Youth.

Advocates for Youth (1990) *Young Women and AIDS: A Worldwide Perspective: The Facts*, Washington, DC: Advocates for Youth.

Alan Guttmacher Institute (The) (1998) *Into a New World: Young Women's Sexual and Reproductive Lives*, New York.

Ali, K.A. (1995) 'Notes on Rethinking Masculinities', in *Learning about Sexuality: A Practical Beginning*, New York: Population Council.

Allsobrook, A. and A. Swift (1989) *Broken Promises*, London: Hodder and Stoughton.

Anderson, A. (1992) 'Education for All: What Are We Waiting For?', New York: UNICEF/Education Program Division (unpublished mimeo).

Aptekar, L. (1988) *Street Children of Cali*, Durham, NC: Duke University Press.

Aptekar, L. (1997) 'Street children in Nairobi, Kenya. Gender differences and mental health', *Journal of Psychology in Africa*, N2, pp. 34–53.

Archer, J. (1984) 'Gender roles as developmental pathways', *British Journal of Social Psychology*, 23, pp. 245–256.

Armstrong, B. (1986) 'Involving Young Men in Family Planning Services', *Planned Parenthood Review*, Fall, pp. 4–6.

Arunodhaya and Anti-Slavery (1999) *Research on the Situation of Child Domestic Workers in Chennai City India*: unpublished research.

ASHOKA (1991) 'Outline of the Work of Natee Teerarojjanapongs' in *ASHOKA Listing of Fellows*, Washington: ASHOKA.

Asociación Hogar Mujercitas (1991) *Diagnostico Situacional de la Niña-Adolescente de la Calle de la Ciudad de Guatemala*, Guatemala: Asociación Hogar Mujercitas.

AVSC International (1997a) *Men as Partners Initiative: Summary Report of Literature Review and Case Studies*, New York: AVSC International.

AVSC International (1997b) *The Family Planning Association of Pakistan's Faisalabad Program for Men: A Case Study*, New York: AVSC International.

AVSC International (1997c) *Profamilia's Clinics for Men: A Case Study*, New York: AVSC International.

Awiti, V. (1991) 'Domestic Workers Training Project: Evaluation Report May 1991', Nairobi: Child Welfare Society of Kenya.

Bagasao, T. (1992) 'Sex Tourism, Street Children and HIV in the Philippines: Lessening Risks in the Poverty Trap', *WorldAIDS*, March, Panos Institute.

Bagasao, T. and I. Fellizar (1992) 'Sex Tourism, Street Children and HIV in

the Philippines: Lessening Risks in the Poverty Trap', unpublished version written for WorldAIDS, the Panos Institute, Manila: Kabalikat ng Pamilyang Pilipino Foundation.
Bagasao, T. and I. Fellizar (undated) 'Program for Homeless Youth and Street Children Engaged in High-Risk Behaviors', unpublished background paper, Manila: Kabalikat ng Pamilyang Pilipino Foundation.
Baguioro, B. (1991) *Using Drama in Education and Children's Theatre as Teaching and Learning Tools*, Manila: Children's Laboratory for Drama in Education.
Bandeira de Ataide, Y.D. (1993) 'Decifra-me ou Devoro-te: Historia Oral de Vida dos Meninos de Rua de Salvador', Sao Paulo, Brazil: Edicoes Loyola.
Barker, G. (1991) 'Reaching the Hard to Reach: Health Strategies for Reaching Urban Adolescent Women', New York: CHILDHOPE.
Barker, G. (1992) 'Adolescent Fertility in Sub-Saharan Africa: Strategies for a New Generation', Washington, DC: Center for Population Options/International Center on Adolescent Fertility.
Barker, G. (1997) 'The John D. And Catherine T. MacArthur Foundations International Grant-Making in Male Involvement: Reflections and Recommendations for Future Grant-Making', Chicago: MacArthur Foundation.
Barker, G. and F. Knaul (1990) 'Exploited Entrepreneurs: Street and Working Children in Developing Countries', New York: CHILDHOPE.
Barker, G., F. Knaul and A. Vasconcelos (1991) 'Development as Empowerment: Brazilian Project Offers Passage to a Better Life for Street Girls', *Passages*, Washington, DC: Center for Population Options/International Center on Adolescent Fertility.
Barker, G. and D. Landau (1991) 'Final Report: Street Girls Strategy Meeting', New York: CHILDHOPE (unpublished mimeo).
Barker, G. and I. Loewenstein (1997) 'Where the Boys Are: Attitudes Related to Masculinity, Fatherhood and Violence toward Women among Low Income Adolescent Males in Rio de Janeiro, Brazil', *Youth & Society*, Vol 29, No. 2, 166–196.
Barker, G. and E.-Mbogori (1992) 'AIDS Awareness and Prevention with Kenyan Street Youth', New York: CHILDHOPE (forthcoming).
Barker, G. and J.S. Musick (1994) 'Rebuilding Nests of Survival: A comparative analysis of the needs of at-risk adolescent women and adolescent mothers in the US, Latin America, Asia and Africa', *Childhood*, Vol 2, pp. 152–163.
Barker, G. and S. Rich (1992) 'Influences on Adolescent Sexuality in Nigeria and Kenya: Findings from Recent Focus Group Discussions', *Studies in Family Planning*, 23, 3: 199–210.
Benett, B. (1997) 'Gender Norms Affect Adolescents', *Network*, Spring. Research Triangle Park, NC: Family Health International.
Bequele, A. and J. Boyden (eds) (1988) 'Combating Child Labour', Geneva: International Labour Office.
Black, M. (1991) 'Philippines: Children of the Cities', Florence: UNICEF Innocenti Studies.

Black, M. (1997) 'Children and Families of Ethnic Minorities, Immigrants and Indigenous People', Summary Report, Innocenti Global Seminar, Florence, Italy: UNICEF International Child Development Centre.

Black, M. and J. Blagbrough (1997) *Child Domestic Workers: A Handbook for Research and Action*, London, UK: Anti Slavery International.

Blagbrough, J. (1995) *Child Domestic Work in Indonesia: A Preliminary Situation Analysis*, London, UK: Anti Slavery International.

Bledsoe, C. and B. Cohen (eds) (1993) *Social Dynamics of Adolescent Fertility in Sub-Saharan Africa*, Washington, DC: National Academy Press.

Bossio, J.C. (1991) 'El Trabajo Infantil en América Latina y en el Mundo (extensión, causas, problemas, tendencias)', in *Seminario Regional Tripartito Latinoamericano sobre la Abolición del Trabajo Infantil y la Protección de los Niños que Trabajan: Nota Sobre los Labores* (Quito, 13–17 de mayo de 1991), Geneva: International Labour Office.

Boyer, D., D. Fine and S. Killpack (1991) 'Sexual Abuse and Teen Pregnancy', *The Network Newsletter of the North Carolina Coalition on Adolescent Pregnancy*, Summer.

Brown, J., A. Newland, P. Anderson and B. Chevannes (1995) 'Caribbean Fatherhood: Underresearched, Misunderstood', Caribbean Child Development Centre and Department of Sociology and Social Work, University of the West Indies, Kingston, Jamaica, October.

Bunster, X. and E. Chaney (1985) *Sellers and Servants: Working Women in Lima, Peru*, New York: Praeger Publishers.

Burra, N. (1989) 'Out of Sight, Out of Mind: Working Girls in India', *International Labour Review*, 128, 5.

Burra, N. (1995) *Born to Work: Child Labour in India*, UK: Oxford University Press.

Cabrera, F., et al. (1991) 'La Prostitución en el Centro de Bogotá', Bogotá: Camara de Comercio de Bogotá.

Casa de Passagem (1997) 'Meninas de Rua do Recife', Brasil.

Castaño Mejia, E. (1989) 'A Prostituicao Infantil', paper presented at the First Latin American Seminar of 'Pedagogia Reeducativa', Medellín, Colombia, 7–10 March.

CPCR (Center for the Protection of Children's Rights) (1991) 'CPCR's Report on Child Rights Violation', December, Bangkok: CPCR.

CPCR (1992a) 'The Growing Child Prostitution Problem in Thailand: Experience of CPCR', Bangkok: CPCR.

CPCR (1992b) 'Project Overview', Bangkok: CPCR.

CPCR (1992c) 'Testimony of the Center for the Protection of Children's Rights at the UN Commission on Human Rights: Rights of the Child', Bangkok: CPCR.

Centro Brasileiro de Infancia e Adolescencia (1990) 'Meninas', Brasilia, Brazil: Centro Brasileiro de Infancia e Adolescencia.

Chaney, E. and M. Castro (eds) (1989) Muchachas *No More: Household Workers in Latin America and the Caribbean*, Philadelphia: Temple University Press.

Chevannes, B. (1996) 'An Evaluation of the Women's Centre of Jamaica Foundation', Kingston, Jamaica: UNICEF.
CHILDHOPE (1987) 'Our Child, Our Hope', Guatemala.
CHILDHOPE (1989a) 'Fact Sheet on Street Children and AIDS/HIV', New York.
CHILDHOPE (1989b) 'Investigación Sobre Niñas y Adolescentes Trabajadoras de la Calle', Guatemala: CHILDHOPE.
CHILDHOPE (1989c) 'The Street Girls of Metro Manila: Vulnerable Victims of Today's Silent Wars', Manila, Philippines: CHILDHOPE.
CHILDHOPE and NESA/State University of Rio de Janeiro (1997) 'Gender, Sexuality and Attitudes Related to AIDS Among Low Income Youth and Street Youth in Rio de Janeiro', *ChildHope Working Paper #6*, January, New York.
Children's Laboratory for Drama in Education (1992) 'Help Wanted: A primer on street education', Manila: The National Project on Street Children.
Cohen, R. (1991) 'Shaping Tomorrow: The Servol Programmes in Trinidad and Tobago', The Hague: Bernard Van Leer Foundation.
COIPRODEN (1993) 'Informe Alternativo, Honduras', Tegucigalpa: COIPRODEN.
Consortium for Street Children UK (1998) *The Human Rights of Street and Working Children*, London, Intermediate Technology Publications.
Consortium for Street Children UK and University of Cork (1999) 'Prevention of Street Migration', Third World–Second Sex.
Contreras, D. (1990) 'Manejo de la adolescente embarazada', *Revista Colombiana de Obstetricia y Ginegologia*, 41, 1, Jan–March.
Davies, M. (ed.) (1987) *Third World–Second Sex*, Vol 2, London: Zed Books Ltd.
de Moya, E.A. (1988) 'Presentation at WHO Consultation on Prevention and Control of STDs in Population Groups at Risk', Geneva.
Demographic and Health Surveys (1992) *Adolescent Women in Sub-Saharan Africa: A Chartbook on Marriage and Childbearing*, Washington: Demographic Health Surveys and Population Reference Bureau.
Diclemente, R., L. Ponton, et al. (1991) 'Prevalence and Correlates of Cutting Behavior: Risk for HIV Transmission' *Journal of the American Academy of Child and Adolescent Psychiatry*, 30: 5, September.
Duque, S. (ed.) (1991) 'Situación de las Adolescentes Centroamericanas: Tendencias y Perspectivas', Guatemala: UNICEF.
Economic and Social Commission for Asia and the Pacific (1991) 'Promotion of Community Awareness for the Prevention of Prostitution', New York: United Nations.
ECPAT (1992) *ECPAT Newsletter*, No. 4, Feb., Bangkok: ECPAT.
ECPAT (1996) 'Regional profile, Latin America and the Caribbean', London: ECPAT.
ECPAT-UK (1997) 'Student Pack', London: ECPAT.
ECPAT-USA (1992) 'Statement of the US Committee to Support the Campaign to End Child Prostitution in Asian Tourism', Washington: ECPAT.
Erikson, E. (1968) *Identity: Youth and Crisis*, New York: W.W. Norton.

Ewart-Biggs, K. (1990) 'The Freedom Trap: The Dreams and realities of the Street Girls of Recife, Brazil', Edinburgh University: unpublished M.A. dissertation.

Felsman, K. (1989) 'Risk and Resiliency in Childhood: The Lives of Street Children', in *The Child in Our Times*, Dugan, T. and R. Coles (eds) New York: Bumner/Mazel Publishers.

Floro, M. and J. Wolf (1990) 'The Economic and Social Impacts of Girls' Primary Education in Developing Countries', Washington, DC: US Agency for International Development.

Folha de Sao Paulo. Various dates, February (1992).

Foundation for Women. (1990) 'Foundation for Women: Brochure', Bangkok: Foundation for Women.

Foundation for Women (1990) *KAMKAEW*, Bangkok: Foundation for Women.

Foundation for Women (1990) *KAMLA*, Bangkok: Foundation for Women.

Frost, D. (1991) *Skills for Life: Experiences of Training in Three Developing Countries*, London, Intermediate Technology Publications.

Fundacion San Gabriel. (1991) 'Background Study on Street and Working Children', unpublished draft, La Paz, Bolivia: Fundacion San Gabriel.

Futures Group (1999) *Situational Analysis of Aids in Zambia*, Lusaka: Ministry of Health.

Gabriela Commission on Children and Family (GCCF) (1991) 'Child of the Times', *GCCF Newsletter*, Vol 2, No. 1 (July 1990–March 1991).

Gaviria, A. (1974) 'El Servicio Domestico: Un Gremio en Extinción', Bogotá: Editorial Controversia.

Gershenson, H., J. Musick, H. Ruch-Ross, V. Magel, K. Rubino and D. Rosenberg (1989) 'The Prevalence of Coercive Sexual Experience Among Teenage Mothers', *Journal of Interpersonal Violence* 4, 2: 204–219.

Giardet, H. (1992) *Cities: New Directions for Sustainable Urban Living*, London: Gaia Books.

Gilligan, C. (1982) *In a Different Voice: Psychological Theory and Women's Development*, Cambridge, MA: Harvard University Press.

Girls Incorporated (1991) 'Truth, Trust and Technology: New Research on Preventing Adolescent Pregnancy', New York: Girls Incorporated.

Gomes, V., J. Caludion Pereira, et al. (1986) 'Pesquisa: Meninas de Rua: Um Estudo de Identidade Social', Goias, Brazil: Estado de Goias, Fundacao Estadual do Bem-Estar do Menor.

Grunsheit, A. and S. Kippax (undated) *Effects of sex education on young people's sexual behaviour*, report commissioned by the Youth and General Public Unit, Office of International Development and Support, Global Programme AIDS. WHO, North Ryde: National Center for HIV Social Research, Macquarie University.

Handa, A. (1996) 'Cost–Benefit Analysis, Women's Centre of Jamaica Foundation', (Appendix to Chevannes, B. (1996) 'An Evaluation of the Women's Centre of Jamaica Foundation'), Kingston, Jamaica: UNICEF.

Hanley, G. (1997) 'Whores! Colonial Discourse and the Gaze on the Street Girls in North-east Brazil', University of California, (unpublished).

Heise, L. (1994) 'Gender-based Abuse: the Global Epidemic', *Caderno de Saúde Pública*, Rio de Janeiro 10 (Supl. 1): pp. 135–145. (Rio de Janeiro: National School of Public Health/ENSP).

Hidalgo, H. (1991) 'Hacia el Rescate de la Menor Afectada por la Prostitución: Programa de Promoción Integral de la Mujer, Religiosas Adoratrices de Colombia', Bogotá: UNICEF.

Hirsch, J. and G. Barker (1992) 'Adolescents and Unsafe Abortion in Developing Countries: A Preventable Tragedy', Washington, DC: Center for Population.Options/International Center on Adolescent Fertility.

Instituto Brasileiro de Geografia e Estatisticas (1989) 'Perfil Estatistico de Criancas e Maes no Brasil', Rio de Janeiro: Instituto Brasileiro de Geografia e Estadisticas.

International Catholic Child Bureau and UNESCO (1995) 'Working with street children: Selected case studies in Africa, Asia and Latin America'.

International Labour Office (1988) 'The Emerging Response to Child Labour', *Conditions of Work Digest*, Vol 7, No. 1.

International Labour Office (1996) *Child Labour: Targeting the Intolerable*, Geneva: International Labour Organisation.

Jagdeo, T. (1984) 'Teenage Pregnancy in the Caribbean', New York: International Planned Parenthood Federation.

Jubilee Campaign (1992) *Street Children in the Philippines* Ed. by Father Shay Cullen, Danny Smith and Nigel Parry, Guildford: Jubilee Campaign.

Kahn, J. and K. Anderson, (1992) 'Intergenerational Patterns of Teenage Fertility', *Demography*, 29,1.

Kapatiran-Kaunlaran Foundation (KKF) (undated) 'Kapatiran-Kaunlaran Foundation: Commitment to God's Mission', Manila: KKF.

Keijzer, B. (1995) 'Masculinity as a Risk Factor', Paper presented at the Coloquio Latinoamericano sobre 'Varones, Sexualidad y Reproduccion', Zacatecas, Mexico, Nov. 17–18.

Kirschenbaum, J. (1990) 'Taking it to the Streets: How One Group Battles a Growing Problem: Homeless Teenagers in Times Square', *Newsday Magazine*, New York, 10 June.

Knodel, J. and G. Jones (1996) 'Post-Cairo Population Policy: Does Promoting Girls' Schooling Miss the Mark?, *Population and Development Review*, 22, No. 4, December, 683–702.

Kotite, P. (ed.) (1989) 'Women's Education Looks Forward: Programmes, Experiences, Strategies', Paris: UNESCO.

Kuleana Centre for Children's Rights (1996) *Kuleana Annual Report*, Tanzania.

Lamarao, M. and M. Santos Oliveira, et al. (1990) 'Cotidiano de Miseria e Formas de Exploracao Sexual de Meninas em Belem', Belem, Para, Brazil: Movimento Republica do Pequeno Vendedor.

Larnaga, M. and L. Soria (1991) 'Mujeres Jóvenes: Testimonios, relexiones y experiencias en el Uruguay de Hoy', Montevideo, Uruguay: Foro Juvenil.

Levison, D. 'Children's Labor Force Activity and Schooling in Brazil', unpublished Doctoral Dissertation, University of Michigan, Ann Arbor, Michigan.

Loewenstein, I. and G. Barker (1998) 'De Onde Vem o Bom Pai? Reflexoes a Partir de Uma Pesquisa Qualitativa com Adolescentes' in Silveira, P. (ed.) *Exercicio da Paternidade*, Porti Alegre, Brazil: Artes Medicas.

Lucchini, R. (1998) Sociologia de la Superviviencia, Universidad Nacional de Mexico, Iztalcala.

Lusk, M. et al. (1989) 'Street Children of Juarez: A Field Study', *International Social Work*, 32, 289–302.

Magee, V. (1989) 'Heart to Heart: A Sexual Abuse Prevention Program for Children of Teenage Mothers', Chicago: Ounce of Prevention Fund.

Mansilla, M. (1989) 'Los Niños de la Calle: Siembra de Hoy, Cosecha de Mañana', Lima: ADOC.

Marchand, D. (1987) 'Paying the Price of Prostitution: Gonorrhea in Thailand', Ottawa: International Development Research Centre Reports.

Minnesota Lawyers International Human Rights Committee (1990) 'Restavek: Child Domestic Labor in Haiti', Minneapolis: Minnesota Lawyers International Human Rights Committee.

Mohamud, A. (1992) 'Female Genital Mutilation: A Continuing Violation of the Human Rights of Young Women', Washington, DC: Passages, Center for Population Options/International Center on Adolescent Fertility.

Moya, E.A. (1988) 'Presentation at WHO Consultation on Prevention and Control of STDs in Population Groups at Risk', Geneva.

Musick, J. (1992) 'Dear Diary: Journals of Adolescent Mothers', (Unpublished mimeo, used with permission of author).

Musick, J. (1993) *Young, Poor and Pregnant: The psychology of teenage motherhood*, New Haven: Yale University Press.

National Health (1990) Special Edition: '1990 The Year of the Girl Child', Karachi, Pakistan.

Ndiaye-Kane, Y. (1985) 'Les 'Mbindaan' ou Employees de Maison de HLM Montagne S'Organisent', Dakar: Enda Jeunesse Action.

NGOs Working Groups on Girls (1998) 'Clearing a Path for Girls: NGOs report from the field on the progress since the Fourth World Conference on Women, Beijing, China', Prepared for the 42nd session of the Commission on the Status of Women, 2–13 March 1998, New York and Geneva.

Ngwana, A. and A. Akwi-Ogojo (1996) 'Adolescent Reproductive Health Rights in sub-Saharan Africa', Washington: CEDPA.

Njovana, F. and C. Watts (1996) 'Gender Violence in Zimbabwe: A Need for Collaborative Action', *Reproductive Health Matters*, No. 7, May.

Nolasco, S. (1995) 'Cultura Brasileira, Patriarcade e Genero', Paper presented at the Coloquio Latinoamericano Sobre Varones, Sexualidad y Reproduccion, November 17–18, Zacatecas, Mexico.

O'Grady, R. (1992) 'The Child and the Tourist', Bangkok: The Campaign to End Child Prostitution in Asian Tourism (ECPAT).

Oloko, B.A. (1991) 'Children's Work in Nigeria: A Case Study of Young

Lagos Street Traders' in *Protecting Working Children*, Myers, B. (ed.) London: Zed Books.
Onyango, P. and K. Orwa (1991) 'A Report on Sample Surveys on Child Labour (Kenya)', Submitted to the International Labour Office, Nairobi: University of Nairobi.
Ordonez Bustamante, D. (1994) 'Ninos de la Calle en Lima: Una realidad en 852 variables', Lima, Peru: AYNI.
Ordonez Bustamente, D. (1995) 'Niños de la calle y sus familias en Lima: Una realidad en 852 variables. Lima, Peru: Peruval.
Palattao-Corpus, L. (1991) 'Situation of Adolescent Filipinos 1991: Focus on Teenage Mothers', paper prepared for UNICEF International Child Development Center, Florence, Italy.
Panniker-Pinto, R. (1988) 'Situation Analysis of Children in Especially Difficult Circumstances', New Delhi: UNICEF/India.
Pantin, G. (1989) 'Revised Servol Programme for the Socio-Economic Development of Adolescents from Working Class Families', Trinidad: Servol.
Pathfinder International (1980) 'The Adolescent Mothers Project in Jamaica', *Pathpapers*, Watertown, MA: Pathfinder International.
Population Council (1989) 'Jamaica: Teen Mothers Return to School', *Alternatives*. September, New York: Population Council.
Population Reference Bureau. (1990) 'Teen Parents, Global Patterns', Washington, DC: Population Reference Bureau.
Pynn, H. (1992) 'AIDS and Prostitution in Thailand: Case Study of Burmese Prostitution in Ranong', MA Dissertation for Massachusetts Institute of Technology, Cambridge.
Radda Barnen (1992) 'Niñas Trabajadoras del Hogar: En el pais de la matachola', Area Chica, (Lima, Peru), 9 Feb.
Rico de Alonso, A. (1991) 'Niñas y Jovenes en Colombia: Realidades, Problemas, y Posibilidades', Report prepared for UNICEF/Colombia, Bogotá.
Rizzini, I. 1995 'Deserdados da Sociedade: "Os Meninos de Rua" da America Latina', *Serie Banco de Dados No. 2*, Cespi/USU, Rio de Janeiro, Brazil.
Ruff, G.B. (1988) 'Low Birthweight/Infant Mortality: Psychosocial Program Initiatives' in *Developing Public Health Social Work Programs to Prevent Low Birthweight and Infant Mortality: High Risk Population and Outreach*, Mortion, C. and R. Hirsch (eds) Berkeley: University of California Berkeley.
Safilios-Rothschild, C. (1982) 'Adolescent Urban Girls in Developing Countries', Washington, DC: Office of Women in Development, US Agency for International Development.
SAVE THE CHILDREN (1993) 'Wish you weren't here: The sexual exploitation of children and the connection with tourism and international travel', by Kevin Ireland, *Working paper* No 7, London.
Schibotto, G. (1990) 'Niños Trabajadores: Construyendo una Identidad', Lima: Instituto de Publicaciones Educación y Comunicación.

Seabrook, J. (1992) 'The Sex Industry in Thailand Part 1 of 3', in *The FACT Sheet*, Vol 20, Bangkok.
Segura Escobar, N. (1992) 'La Prostitutión Infantil: Mitos y Realidades de una Población Marginalizada', unpublished research report to UNESCO, Universidad del Valle.
Senderowitz, J. and J. Paxman (1985) 'Adolescent Fertility: Worldwide Concerns', Washington, DC: Population Reference Bureau.
Servol (1990) 'Servol Through the Years 1970–1989', Trinidad: Servol.
Servol (1991) 'Working Your Way Through Servol', Trinidad: Servol.
Servol (undated) 'What does Servol do', Trinidad: Servol.
Servol (undated) 'Servol Goes High Tech', Trinidad: Servol.
Shepard, B. (1996) 'Masculinity and the male role in sexual health', *Planned Parenthood Challenges*, 1996/2, New York: International Planned Parenthood Federation.
Simonetti, C., V. Simonetti and S. Arruda (1995) 'Listening to Boys: A talk with ECOS Staff', in *Learning about Sexuality: A Practical Beginning*, New York: Population Council.
Simons, J., B. Final and A. Yang (1992) *The Adolescent and Young Adult Fact Book*, Washington, DC: Children's Defense Fund.
Singh, N. (1991) 'Invisible No More: The Story of Home-Based Workers', New Delhi: International Labour Office.
Singh, S. and D. Wulf (1990) 'Today's Adolescents, Tomorrow's Parents: A Portrait of the Americas', New York: Alan Guttmacher Institute.
Sittitrai, W. (1991) 'Multi-Stage Interventions for Sex Workers in Thailand', AIDS and Reproductive Health Network Newsletter, Boston.
Skrobanek, S., N. Boonpakdee and C. Janteero (1997) *The Traffic in Women: Human Realities of the International Sex Trade*, London/New York: Foundation for Women.
Sonenstein, F., J. Pleck and L. Ku (1995) 'Why Young Men Don't Use Condoms: Factors Related to the Consistency of Utilization', The Urban Institute, Washington, DC, June.
Stricof, R., et al. (1991) 'HIV Seroprevalence in a Facility for Runaway and Homeless Adolescents', *American Journal of Public Health*, May, Vol 81, special supplement.
Swift, A. (1991) 'Brazil: The Fight for Childhood in the City', Florence: UNICEF Innocenti Studies.
TABAK-Philippines (1995) 'A quest for a fairytale: Mamanwa children's domestic experience', unpublished report.
Tall, P. (year unknown) 'Copines of the Street', Dakar, Senegal: Enda.
Tietjen, K. (1991) 'Educating Girls: Strategies to Increase Access, Persistence, and Achievement', Washington, DC: US Agency for International Development.
Thomson, M. (1998) 'Trip Report: United Nations Commission on the Status of Women, New York, Feb 28–March 8, 1998', Save the Children, UK.
Tobia, N. (1995) 'Female Genital Mutilation: A Call for Global Action', New York: RAINBO.
Treguear, T. and C. Carro (1990) 'Diagnostico Situacional de la Niña

Trabajadora de y en la calle (Costa Rica)', San Jose, Costa Rica: UNICEF and PROCAL.
Ughetto, C. and V. Moreira, et al. (1988) 'Meninas de Rua: Um Estudo Preliminar no Rio de Janeiro', Guatemala: CHILDHOPE.
UNICEF (1991) *The State of the World's Children*, Oxford and New York: Oxford University Press.
UNICEF (1992) *The State of the World's Children*, Oxford and New York: Oxford University Press.
UNICEF (1993) *The State of the World's Children*, Oxford and New York: Oxford University Press.
UNICEF (1994) *The State of the World's Children*, Oxford and New York: Oxford University Press.
UNICEF (1995) *The State of the World's Children*, Oxford and New York: Oxford University Press.
UNICEF (1996) *The State of the World's Children*, Oxford and New York: Oxford University Press.
UNICEF (1997) *The State of the World's Children*, Oxford and New York: Oxford University Press.
UNICEF (1998) *The State of the World's Children*, Oxford and New York: Oxford University Press.
UNICEF (1995) 'The trafficking and prostitution of children in Cambodia: Situation report, regional workshop on trafficking for sexual purposes', New York.
UNICEF (1999) 'Child Domestic Workers', *Innocenti Digest*, No. 2: Innocenti Centre.
UNICEF-Brazil, et al. (1991) 'O Trabalho e a Rua', Brasilia.
UNICEF-Kenya, Government of Kenya (1989) 'Situation Analysis of Children and Women in Kenya', Nairobi.
UNICEF, Save the Children-Canada, Procosi, Comite Civico Femenino de Santa Cruz de la Sierra (1991) 'La Poblacion Ignorada: 1er Congreso Nacional sobre la situacion de la niña adolescente de y en la calle en Bolivia', La Paz, Bolivia.
United Nations. (1988) '1988 Revision, Global Estimated and Projects of Population.by Age and Sex', New York.
United Nations. (1989) 'Adolescent Reproductive Behavior: Evidence from Developing Countries, Volume II', New York: United Nations, Department of International Economic and Social Affairs.
Urban and Rural Systems Associates (1976) 'Improving Family Planning Services for Teenagers', Washington, DC: Department of Health and Human Services, Publication 81-5628.
Vasconcelos, A. (1989) 'SOS Meninas', Recife: Casa de Passagem.
Vasconcelos, A. (1990) 'Street Girls: Emancipation or Help', Amsterdam: Institute for Development Research.
Vasconcelos, A. (1991) 'Programa Agentes Multiplicadores de Defesa da Saude', Recife, Brazil: Centro Brasileiro de Crianca e do Adolescente, Casa de Passagem (unpublished mimeo).
Vasconcelos, A. and J.B. Feres (1991) 'Education Through Life: An Experience in Education in Brazil' (translated by S. Bailey) Amsterdam: Indra.

Vitiello, N. (date unknown) 'Violencia Sexual Contra Criancas e Adolescentes', Brazil: Coordenodor de Servico de Assistencia Integral a Adolescencia.

Weiner, M. (1991) *The Child and the State in India*, Princeton: Princeton University Press.

Weinert, P. (1991) 'Foreign Female Domestic Workers: Help Wanted!', Geneva: International Labour Office, March.

Women's Centre of Jamaica Foundation (The) (1995) 'Tracer Study of Clients of the Kingston and Mandeville programmes of the Women's Centre, 1978–1990', Kingston, Jamaica.

Women's Centre of Jamaica Foundation (The) (1997) *Annual report*.

World Bank (1991) 'Letting Girls Learn', Washington, DC: World Bank.

World Bank (1993) *World Development Report 1993: Investing in Health*, New York: Oxford University Press.

World Bank (1998) 'Findings News Letter' by the Knowledge Management and Learning Centre, African Region, Washington DC.

WHO (World Health Organization) (1989) 'The Risks to Women of Pregnancy and Childbearing in Adolescence', Geneva: WHO, Division of Family Health.

World Vision-UK (1996) 'The Commercial Sexual Exploitation of Street Children', report produced by the Policy and Research Department of World Vision UK.

Wright, A. (1987) 'The Girls of Jeunesse Action: A Sociological Study of Street Youth in Dakar', Dakar, Senegal: Enda.

Consortium for Street Children Profile

The Consortium for Street Children is a group of development agencies which provide funding, operational partnership (levering funds from statutory bodies), training, technical and campaigning support to projects for children who live on the street, who work on the street, or who are at high risk of taking to street life in the developing world and Eastern Europe.

Full Members:
Action UK
AHRTAG
CARF
Casa Alianza UK
Childhope UK
Children of the Andes
The Child to Child Trust
Estrela
Hope for Children
ICDP
International Childcare Trust
International Children's Trust
Jubilee Action
Let the Children Live!
Link Romania
Merdeka
New Ways
The Railway Children
SKCV Children's Trust
The Society of Friends
 of the Lotus Children
Street Child Africa
Street Kids International
University of Cork Child Studies Unit
Womankind Worldwide
WAGGGS
World Vision UK
YCare International

Observer Members:
Amnesty International
Anti-Slavery International
ECPAT UK
Save the Children Fund UK
UK Committee for UNICEF

International Advisory Board:
Sarah Thomas de Benitez, President,
 META Federation
Bruce Harris, Director, Casa Alianza
Dr. Dwight Ordoñez Bustamente
Dr. Irene Rizzini, CESPI, University
 of Sta Ursala
Professor Geraldine van Bueren, Queen
 Mary and Westfield College

Address: Thomas Clarkson House, The Stableyard, Broomgrove Road, London SW9 9TL UK
Email: cscuk@gn.apc.org
Tel./Fax: +44 (0) 207 274 0087
Charity Reg. No: 1046579
Director: Anita Schrader
Chair: Ana Capaldi
Vice-Chair: Clare Leu Hanbury

CSC members working with at-risk girls and young women

Work with urban girls and young women undertaken by member agencies of the Consortium for Street Children UK

Anti-Slavery International

Thomas Clarkson House
The Stableyard
Broomgrove Road
London
SW9 9TL

Tel: +44 (0) 207 924 9555
Fax: +44 (0) 207 738 4110
Email: antislavery@gn.apc.org
Internet: www.charitynet.org/~ASI

Brief description of our work
Anti-Slavery International (ASI) promotes the eradication of slavery and slavery-like practices, and freedom for everyone who is subjected to them. The abuses which ASI opposes include: abusive forms of child labour; debt bondage; forced labour; trafficking of women and the predicament of migrant workers who are trapped into servitude; early or forced marriage and other forms of servile marriage.
 ASI works by:

o Collecting information about these abuses, bringing them to the attention of the public and promoting public action to end them;
o Indentifying ways in which these abuses can be brought to an end, and influencing policy-makers in governments or other institutions at national and international level to take action;
o Supporting victims of these abuses in their struggle for freedom, in particular by working with organizations they establish and other organizations campaigning on their behalf.

Are girls included in the programmes?
Opposing the abuse of girls and young women is an integral part of ASI's work. In particular, ASI continues to highlight, through research and campaigning activities, the abuse and exploitation of child domestic workers, the majority of which are girls.

Separate programmes for girls/young women
ASI has produced a handbook in English, French and Spanish, for research and action on child domestic workers, providing a step by step

guide to NGOs in finding out about and acting on the situation of child domestic workers.

Casa Alianza UK

The Coach House
Grafton Underwood
Kettering, Northants.
NN14 3AA

Tel: +44 (0) 1536 330 550
Fax: +44 (0) 1536 330 718
Email: casalnzauk@gn.apc.org
Internet: http://www.casa-alianza.org

Brief description of our work

Casa Alianza is an independent, non-profit organization dedicated to the care and defence of street children in Guatemala, Honduras, Mexico and Nicaragua.

Founded in Guatemala in 1981, and expanded into three other countries since, Casa Alianza monitors and cares for mistreated children, most of whom have been made orphans by civil war, abused or rejected by poverty-stricken families and traumatized by the societies in which they live.

Separate programmes for girls/young women

Mexico, Honduras, Guatemala

Casa Alianza provides long term residential and non-residential rehabilitation programmes for street girls up to the age of 18. Services include medical, nutritional and mental health, plus job training and non-formal education.

Mexico, Guatemala

Casa Alianza provides residential services for adolescent mothers and their babies. These services include health, nutrition and job skills training for the mothers. Programmes to help mother and child bonding and to involve the father (if known) in the inherent responsibilities are also implemented.

Mexico

Casa Alianza operates a hospice for street girls in final stages of full-blown AIDS. This residential programme provides medical and emotional support for the street girl and her family or friends.

Children at Risk Foundation

3 The Orchard
London
W4 1JZ

Tel: +44 (0) 208 994 7004
Fax: +44 (0) 208 987 9012

CARF UK supports a project for both boys and girls in Sao Paolo, Brazil. It offers street living children a year's stay in a halfway house which prepares them for state schooling, and eventual foster care. A vocational training centre is in construction.

Childhope UK

Lector Court
151 Farrington Road
London
EC1R 3AD

Tel: +44 (0) 207 833 0868
Fax: +44 (0) 207 833 2500
Email: chuk@gn.apc.org
Internet: www.childhopeuk.org

Separate programmes for girls/young women

1. Street Girls Project in Kenya
A project for street girls and their families, a pilot project established on the principle of reuniting street girls with their families. A rural, residential halfway house was established to rebuild relationships and return families to their original rural homesteads.

2. Casa da Passagem in Recife, Brazil
Provides an open day centre, providing food, shelter, and elementary education and counselling. This skills centre provides an opportunity to generate some income.

3. Ons Plek, Cape Town, South Africa
Offers services to female street children through two project houses. Aims at rebuilding family links or providing foster care options.

4. Kalookan Drop in Centre
Street Educators work with prostituted and abused girls and refer them to the Kalookan centre where they are provided with counselling and support for up to 6 months before either reuniting them with their families or referring them to other centres offering services on a longer term basis. The project also involves advocacy through local networks on issues of child abuse and women's rights.

5. Pendekezo Letu, Maragua, Kenya
PL recruits girls from the streets and provides them with shelter at a centre about 70km from Nairobi where they feel safe and are away from the hazards of street life. Here they have an intensive schooling programme for 6 months and participate in various recreational activities – singing, dancing, puppetry and assist in farming work. After the 6 months they

return to their original rural communities to live with extended family or their immediate family which has relocated through the assistance of PL.

PL works with the girls' families assisting them to relocate upcountry, usually to the villages from which they originally migrated, with the assistance of housing loans. They are also provided with business training and business loans. It is usually the mother or grandmother who will be involved in this part of the project as there are many single headed families. By working with girls, PL is ensuring that this generation of street children has the chance of receiving an education and building their lives in their rural communities and not following the path taken by their mothers of migrating to the city's slums.

Child-to-Child Trust

Institute of Education
20 Bedford Way
London
WC1H 0AL

Tel: +44 (0) 207 612 6648
Fax: +44 (0) 207 612 6645
Email: c.scotchmer@ioe.ac.uk

Brief description of our work
Materials production and dissemination, training, information base to encourage the role of children in health promotion.

Are girls included in the programmes?
Child-to-Child activities in 60+ countries nearly all include girls as providers and receivers of health, information and health care.

Separate programmes for girls/young women
In 1999 we will have available a Child-to-Child: Girl Child series of story books which highlight issues of concern to girls including access to education and son preference. They will be published by Assison Wesley Longman and aimed primarily at girls and boys in English speaking Africa.

Children of the Andes

4 Bath Place
Rivington Street
London
EC2A 3DR

Tel: +44 (0) 207 739 1328
Fax: +44 (0) 207 739 5743
Email: info@children-of-the-andes.org
Website: www.children-of-the-andes.org

Children of the Andes was set up in 1991 to support organizations dedicated to building a future for street children and children at risk in Colombia.

Street Girl Project in Bogota
Aprendiendo a Vivir (Learning to live), based in Bogota, is dedicated to supporting vulnerable girls. Since 1996 Aprendiendo a Vivir has provided protection and care for 30 teenage girls at risk. The programme is designed to provide food, shelter, training and psychological intervention.

The girls also gain self-respect and independence. Most of the girls are of peasant origin. Their families have been displaced and have settled down in the slums of the capital Bogota. Girls are often abused at home, forced into prostitution or single motherhood before they reach the age of 16. Few learn any skills they can use to make a home or earn a living, and most never have the chance to escape the life they were born into before passing the legacy of despair to their own children. Our work with Aprendiendo a Vivir is breaking that cycle.

Estrela

19 Powell Street	Tel: +44 (0) 1429 265379
Hartlepool	Fax: +44 (0) 1429 266918
TS26 9BN	Email: estrela@atarde.com.br

Brief description of our work
Estrela aims to advance education and awareness, by means of creative activity and cultural exchange, for the benefit of communities in Brazil and the United Kingdom. To develop equality opportunities for traditionally marginalized groups, we work primarily with young people at risk (eg. street children and shantytown youths), girls and women, learning disabled and black communities.

Separate programmes including girls/ young women
Estrela currently supports projects in Brazil initiated by the above groups, combining education for citizenship with creative skills training (theatre, circus, *capoeira* and handicrafts). This includes support for an all girls' theatre group in a periphery area of Salvador. Exchanges are facilitated between groups with common objectives to strengthen their struggles against discrimination. Development education in the UK emphasizes the strength of popular movements and cultural resistance in Brazil

Healthlink Worldwide (formerly AHRTAG)

Farringdon Point	Tel: +44 (0) 207 242 0606
29–35 Farringdon Road	Fax: +44 (0) 207 242 0041
London	Email: info@healthlink.org.uk
EC1M 3JB	Internet: www.healthlink.org.uk

Brief description of our work
Healthlink Worldwide works to improve the health of poor and vulnerable communities by strengthening the provision, use and impact of information.

Healthlink does this by: communicating about health issues, promoting the development of good policy and practice, providing training in information management and dissemination, and supporting partners in health information and publishing activities.

Separate programmes for girls/young women
Healthlink has a number of specialist programmes including AIDS and sexual health, child health and disability programmes. Girls and young women are recognized as being particularly vulnerable and all of our work has a gender sensitive approach.

International Childcare Trust

Unit 3L Leroy House
436 Essex Road
London
N1 3QP

Brief description of our work
ICT works in the developing world only with the most deprived sections of the given country. It engages an in-country director who supervises projects of affiliates/partners whose work ICT sponsors. ICT sponsors practical projects benefiting street and working children, destitute and/or displaced families, and programmes for health and environment. These include welfare and training.

Are girls included in our programmes?
Girls and women are included in all programmes we sponsor but within the traditional cultural expectations of the specific country.

Separate programmes for girls/young women
None. As most projects will include elements, sometimes separate from the overall programme, which give greater significance to girls and young women and encourage their fuller practical participation in society.

International Child Development Programme
ICDP
PO Box 262
Watford
WD1 7GS

Brief description of our work
ICDP aims to promote long-term help for children, by sensitizing caregivers to their children's needs. For this purpose ICDP has developed a simple programme, based on recent research in child development. ICDP offers training in its early psycho-social intervention programme to both professionals and paraprofessionals working with children and families. The programme sensitizes and enriches the relationship between caregivers and their children. If children do not receive sufficient love and attention while they are young, the problem also perpetuates itself because later on they become inadequate parents. ICDP's focus is on trying to break this cycle. It does so by reactivating the existing caring skills and network that have been overlaid by stresses related to extreme poverty, social uprooting, migration, war and disaster.

Are girls included in our programmes?
ICDP targets caregivers of children of both sexes from birth to 11 years of age. The programme starts with an assessment of the caregiver's existing skills and styles of caring as part of a cultural way of life, and appropriate in relation to a child's condition and needs. Caregivers are involved in exercises and activities based on their own experiences. Change in their caring practice is achieved through a process of consciousness raising and, therefore, is in line with their culture. This approach is in line with our belief that competence building is the key to sustainable development.

Separate programmes for girls/young women
The ICDP programme is being used to assist very young mothers. Projects in Colombia and Angola included working with young prostituted girls, as well as young mothers who have been institutionalized by the police for various acts of breaking law in the streets. The programme serves as a tool to sensitize girl mothers to their own baby's needs, as well as to create self esteem and confidence in their own caring skills.

Jubilee Action

St Johns
Cranleigh Road
Wonersh
Guildford, Surrey
GU5 0QX

Tel: +44 (0) 1483 894787
Fax: +44 (0) 1483 894797
Email: info@jubileecampaign.demon.co.uk

Brief description of our work
Jubilee Action is a Christian based charity working for street children and for the protection of religious liberty worldwide. It has projects in Brazil, India, China, Uganda and the Philippines, with plans to launch new ones in other countries.

Separate programmes for girls/young women
Jubilee Action's initiatives to protect children's rights and rescue Street Children has resulted in numerous children being saved from often perilous conditions in several countries and a number of Children's Homes have been built. These include the Princess Diana Home for girls in Brazil, and a home in Bombay for girls. Jubilee also supports a number of projects in the Philippines run by Father Shay Cullen and his team. Also as a result of Jubilee's commitment a key orphanage in China has our support. The appalling effects of China's one child policy shocked the world when a Channel Four documentary showed China's Dying Rooms, where abandoned children were left to die alone. As a result of Jubilee's initiative the children now have somewhere to live and have the practical care they need and also gain education.

Let the Children Live!

PO Box 11
Walsingham
Norfolk
NR22 6EH

Tel: +44 (0) 1328 823456
Fax: +44 (0) 1328 823456
Email: funuini@epm.net.co
Internet: www.letthechildrenlive.org

Brief description of our work
Relieving children and young people who live on the street, and helping prevent others from taking to the street, through the provision of social, educational and medical care and support.

Separate programmes for girls/young women
We support some organizations that specifically work with girls, particularly sexual workers.

Railway Children

Foundation House
7–11 Macon Court
Herald Drive
Crewe, Cheshire
CW1 6WA

Tel: +44 (0) 1270 251571
Fax: +44 (0) 1270 251571

Brief description of our work
The Railway Children trustees decided to focus their funds on NGO partners which work on railway or bus stations as this is one of the most likely locations at which newly abandoned or runaway children could be found. By concentrating here, newly arrived children were possibly more amenable to accepting help, thus avoiding further, severe exploitation.

Are girls included in the programmes?
Most of the Railway Children partners work with children of both sexes, but a few concentrate on girls who are working or living on the street. Whilst in most cities girls form a small minority of street living children, in India the proportion is much higher (up to 47% Calcutta, according to a 1996 UNICEF survey) for reasons that are not wholly clear.

Do you have separate programmes for girls/young women?

Nairobi, Kenya
Programme 'Pendekezo Letu' run by a local NGO in conjunction with Childhope. It seeks to help young teenage girls, often with their mothers, find alternatives to prostitution, and reconcile them with their family in rural environments.

Howrath, Calcutta, India
With a local NGO, SEED, 30 young girls were identified sleeping rough at Howrath station, and are receiving counselling and health care, basic education and development advice through social workers and educators.

Vijayawada, India
A project at this large railway junction, includes girls, who are becoming increasingly visible and are vulnerable to prostitution. Run through SKCV, it focuses on providing shelter.

CINI Asha, Rambagan Project, Calcutta
CINI Asha runs widespread and comprehensive programmes for children in Calcutta. These include a scheme for the care and education of children of sex workers. Some 400 3–11 years old and 40 teenagers form part of this initiative.

Save the Children Fund UK (SCF)

17 Grove Lane Tel: +44 (0) 207 703 5400
London Fax: +44 (0) 207 703 2278
SE5 8RD Internet: www.savethechildren.org.uk

Brief description of our work
Save the Children is one of the UK's leading international children's charities and works to create a better future for children. In a world where children are denied basic human rights, we champion the right of all children to a happy, healthy and secure childhood. SCF puts the reality of children's lives at the heart of everything we do. Together with children, we are helping to build a better world for present and future generations.

Separate programmes for girls/young women
Save the children works towards ensuring that the principles of the UN Convention on the Rights of the Child become the foundation for all action concerning girls. We do this through making girls visible in our work, designing programmes and projects which focus on the realization of girls' rights, advocating for long-lasting changes in attitudes towards girls, and pressing for the implementation of the UN Convention on the Rights of the Child in a gender-specific way at national and international levels.

SKCV Children's Villages

5 Trinity Road Tel: +44 (0) 161 969 6718
Sale Fax: +44 (0) 161 973 5042
Cheshire
M33 3FB

SKCV (Street Kids Community Villages) provides night shelters, long term accommodation, and health facilities for children at risk, as well as education, vocational training and support services. This takes the form of two separate but interlinked programmes for boys and for girls.

Street Child Africa

Oak Lodge Tel: +44 (0) 208 906 2627 or
48 Totteridge Common +44 (0) 208 959 1515
London Fax: +44 (0) 208 959 7421
N20 8LZ Email: bundockhague@hotmail.com
 elaine.cousins@Talk21.com

Brief description of our work

Street Child Africa is an organization founded to be a fundraising advocacy/information channel/lobbying partner for small African NGOs which work exclusively with street children in African towns and cities. It was started by Fr Patrick Shanahan who is one of the founder members of two such agencies in Accra, Ghana.

The objective of Street Child Africa is to co-operate with all organizations and groups interested and involved in projects to benefit street children in Africa. Its aim is to act as an umbrella for existing agencies working for street children in Africa. It exists to raise funds for service delivery, offer advocacy to agencies and individual children, share information with other comparable organizations and assist in developing new approaches to working with street children in Africa.

Are girls included in our programmes?

SCA supports agencies rather than running programmes of its own. Currently all agencies associated with SCA include girls in their programmes and SCA anticipates that the majority of agencies we become associated with in the future will also include girls.

Separate programmes for girls/young women

Street Girls Aid (S.AID), Accra, Ghana

S.AID was founded in 1994 to work specifically with street girls aged 18 and under. It runs a Refuge where girls are offered help with ante-natal and post-natal care, including up to six months residence if necessary to assist them to learn to care for their babies. The project offers encouragement to the girls to continue their education and/or vocational training, to find jobs where possible or, occasionally, facilities to start/expand small businesses; it offers counselling and advice for girls who wish to re-establish contact with their families.

S.AID also run a babies programme. This includes eight creches in various areas of the city where the girls can leave their babies (0–5 years) in safety to enable them to continue to work. The creches provide protection, food, healthcare, play, and basic nursery/infant education.

Street Kids International

398 Adelaide St W
Suite 1000
Toronto, ON
Canada
M5V 1S7

Tel: +1 416 504 8994
Fax: +1 416 504 8977
Email: ski@streetkids.org
Internet: www.streetkids.com

Brief description of our work
SKI confronts why some children and youth around the world are forced onto the street, and helps them achieve dignity and self-reliance, health and security.

SKI works with agencies in Asia, Africa and Latin America to build their capacity to support street and working children and youth through the exchange of knowledge and best practices among youth workers and their agencies. SKI develops resources and conducts workshops for front-line workers on the themes of drug use, AIDS and other sexually transmitted diseases.

SKI is developing the Street Business Toolkit, a set of educational materials to be used by youth workers to help street youth develop their business and life skills so that they may set up or improve their own businesses. SKI supports partner agencies build programmes to assist youth in starting small businesses in Ecuador, Zambia and India.

Are girls included in the programmes?
The partner agencies supported by SKI in Zambia, Ecuador and India all include young girls. In Zambia, the Youth Skills Enterprise Initiative has been a successful catalyst in changing the lives of the adolescent women who make up approximately 65% of the participants. This past year 49% of youth benefiting from the 'Building Our Future Program', a business education and start-up project, of the Program for Working Children (PMT), in Ecuador, were young women. At PMT 21% of those attending the Centre for Working Children, a business and job readiness programme, were young girls. Nanban, in Madurai, is currently setting up a workshop for autorickshaw repair and 30% of youth trained at this workshop will be young girls.

Separate programmes for girls/young women
SKI is collaborating with a local agency in the Dominican Republic, CEPROSH, to develop a pilot project geared at young women in the sex trade who are seeking alternative ways to generate income. The project includes focus group assessment, training development and accessing community support information.

UK Committee for UNICEF

55 Lincoln's Inn Fields	Tel:	+44 (0) 207 405 5592
London	Fax:	+44 (0) 207 405 2332
WC2A 3NB	Email:	info@unicef.org.uk
	Internet:	www.unicef.org.uk

Brief description of our work
UNICEF is mandated by the United Nations General Assembly to advocate for the protection of children's rights, to help meet their basic needs and expand their opportunities to reach their full potential.

Separate programmes for girls/young women
UNICEF's programmes for girls/young women are separated into three different categories:

1. Education
UNICEF has redoubled its efforts to tackle the exclusion of girls from schools, their dropout rates and their low achievement.

2. Health
UNICEF has become a strong advocate for the girl child, incorporating an age perspective into its 'women in development' concerns. The health risks of early marriage have led UNICEF to advocate raising the age of marriage. In spite of the sensitivities surrounding practices connected to the intimacies of sexual life and cultural values, UNICEF actively discourages female genital mutilation on grounds of maternal and girl health. The role of maternal healthcare is regarded by UNICEF as vital. While helping women to mobilize for structural change, UNICEF remains dedicated to specific interventions to improve female health at all ages, as a social imperative for children and as a matter of girls' and womens' rights. The spread of child prostitution undermines growing national and international efforts, strongly advocated by UNICEF, to end the neglect and discrimination suffered by girls and to support the equal participation of women in development.

3. Economy
UNICEF supports female income generation projects and community credit schemes such as the Grameen Bank.

Womankind Worldwide

Viking House
5–11 Worship Street
London
EC2A 2BH

Tel: +44 (0) 207 588 6096
Email: info@womankind.org.uk

Womankind works with partners in Africa, South Asia and Latin America to develop the capacity of women, including adolescents, in four key areas that we term the 'four literacies' – Body Literacy, Money Literacy, World Literacy and Civil Literacy.

Together we cover a wide variety of issues, from offering credit to eliminating female genital mutilation in Ghana from educating girls to getting women into local government in India; and from running traditional literacy classes to ending violence against women in Latin America.

In all these cases, and more, we work with community-based women's groups at the grassroots level to achieve real, sustainable change and respect for women's human rights.

Ensuring that our partners' voices are heard and their rights recognized at national and international level is key to all our activities. To this end Womankind runs a programme of advocacy, 'Women's Rights for Development', adding value to our hands-on work on the ground.

World Association of Girl Guides and Girl Scouts

World Bureau
Olave Centre
12c Lyndhurst Road
London
NW3 5PQ

The World Association of Girl Guides and Girl Scouts' mission is: to enable girls and young women to develop their fullest potential as responsible citizens of the world. Through its national Member Organizations in 140 countries with 10 million members. WAGGGS provides a dynamic, flexible, values-based and non-formal educational programme, that is relevant to the needs of girls and young women.

Girls and young women are the focus of all of WAGGGS' work. Two projects in particular, 'Building World Citizenship – the WAGGGS Perspective' and the Health of Adolescent Refugees Project ('HARP') relate especially to girls.

Under the theme 'Health', which is one of four themes in Building World Citizenship, Member Organizations are involved in many projects that are specifically focused on issues affecting girls' reproductive and sexual health. For example, the Gambia Girl Guides Association is involved in raising awareness on sexually transmitted diseases, AIDS, female genital mutilation, teenage pregnancy and early marriages. The Girl Guides Association of Bahrain is involved in raising awareness about reproductive health and contraception. The Girl Guides of Australia organize workshops that encourage girls to have a positive image of their bodies and to increase their self esteem. The Bahamas Girl Guides Association is working with girls to prevent the spread of HIV. The Catholic Guides of Ireland organizes a programme which raises awareness in young girls of issues involving drugs and alcohol.

Under the HARP project, the main focus is improving refugee's health,

particularly of internally displaced adolescent girls and young women. Existing health programmes tend to be geared towards children or women, with adolescents fitting into neither category. This project, by using the Girl Guide/Girl Scout methods and health education activities including peer counselling, improves the knowledge and experience of adolescent refugee girls, encouraging them to identify their own health needs and to make their own decisions regarding reproductive health. WAGGGS estimates approximately ten new groups of female adolescent refugees will be established in Zambia, Uganda, and Egypt. Each group will be made up of about 30 girls, resulting in some 900 refugee girls acquiring information on their own reproductive health and the health of their families. Partners of the HARP Project include the United Nations Population Fund (UNFPA) and Family Health International (FHI).

World Vision UK

599 Avebury Boulevard Tel: +44 (0) 1908 841000
Milton Keynes Fax: +44 (0) 1908 841015
MK9 3PG Email: info@worldvision.org.uk

Brief description of our work
World Vision is an organization with a fifty-year history of commitment to improving the lives of children and speaking out on issues which affect children's lives. As such, it has been well aware that the future of an individual child, girl or boy, is entwined with the future of his or her own community. Effective development work, therefore, should contribute to strengthening families and communities, and to reducing or preventing the exploitation of children.

Do you have separate programmes for girls/young women?
World Vision's Girl Child Initiative has raised and made explicit the organization's commitment to address issues which affect girls, and has helped provide a focus and a deeper commitment for many World Vision offices. There is no centrally directed project office, as the cultural, social, economic and environmental contexts for girl-focused programmes are so varied, and for the same reason there is no single project design.

In India, programmes in Tamil Nadu are working to reduce female infanticide. In Bangladesh, we have sought to raise awareness of problems facing girls through a range of programmes. In Phayao Province Thailand, our project focuses on assisting girls from poor rural families with special skills, and low interest loans. A vital part of the initiative focuses on advocacy.

Y Care International

640 Forest Road
London
E17 3DZ

Tel: +44 (0) 208 520 5599
Fax: +44 (0) 208 503 7461
Email: enq@ycare.ymca.org.uk
Internet: www.oneworld.org/ymcacare

Brief description of our work

Y Care International is the international development agency of the YMCA movement. In keeping with YMCA international policy, Y Care International focuses on the needs and contributions of young people in the developing world who face the severest of economic and social conditions.

Y Care International seeks to support young people and their communities by providing financial support for projects which aim to promote self sufficiency.

Y Care International's programme focuses on the following areas:

o Street Children
o Working Children and Child Labour
o Education and Vocational Training
o Girls and Young Women
o HIV/AIDS Awareness
o Drug Awareness and Rehabilitation
o Disability
o Refugees/Human and Natural Disasters

Separate programmes for girls/young women

Girls and young women particularly face difficulties in developing countries. The disadvantages of poverty often combine with second class legal status and the largest share of household and family responsibility. Girls and young women are at risk from unemployment, unplanned pregnancy, unsafe abortion, rape and other violent acts. Often they are forced or driven into prostitution.

Y Care International seeks to support young girls and women by addressing these issues which affect them. Some of the programmes include literacy, vocational training, income generation, and health care provision.